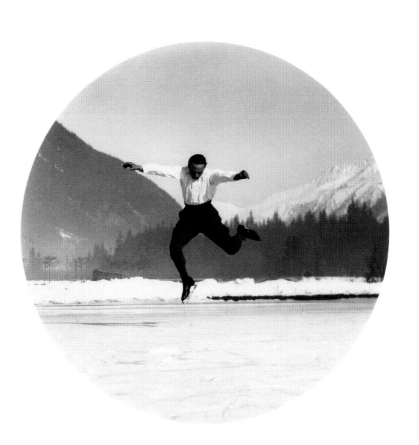

Editorial direction
Suzanne Tise-Isoré

Editorial assistance
Élisabeth Foch
Selma Zarhloul

Art direction
Martine d'Astier de la Vigerie

Graphic design
Bernard Lagacé

Proofreading
Penelope Isaac

Digital imagery and color separation
Guillaume Fleureau, Jean-Christophe Domenech,
and Guillaume Geneste at La Chambre Noire, Paris

Simultaneously published in French as *Lartigue en hiver*
© 2002 Flammarion
English-language edition
© 2002 Flammarion
26, rue Racine 75006 Paris

Photographs and archival material
© 2002 Ministère de la Culture-France/AAJHL
Donation Jacques Henri Lartigue
19, rue Réaumur 75003 Paris

ISBN: 2-0801-0890-5
Publication number: FA0890-02-IX
Dépôt légal: 10/2002

PRECEDING PAGE
Francis Pigueron, Chamonix, France, January 1918.

Lartigue's
Winter
Pictures

Text by Élisabeth Foch

Photographs selected by Martine d'Astier de la Vigerie

Flammarion

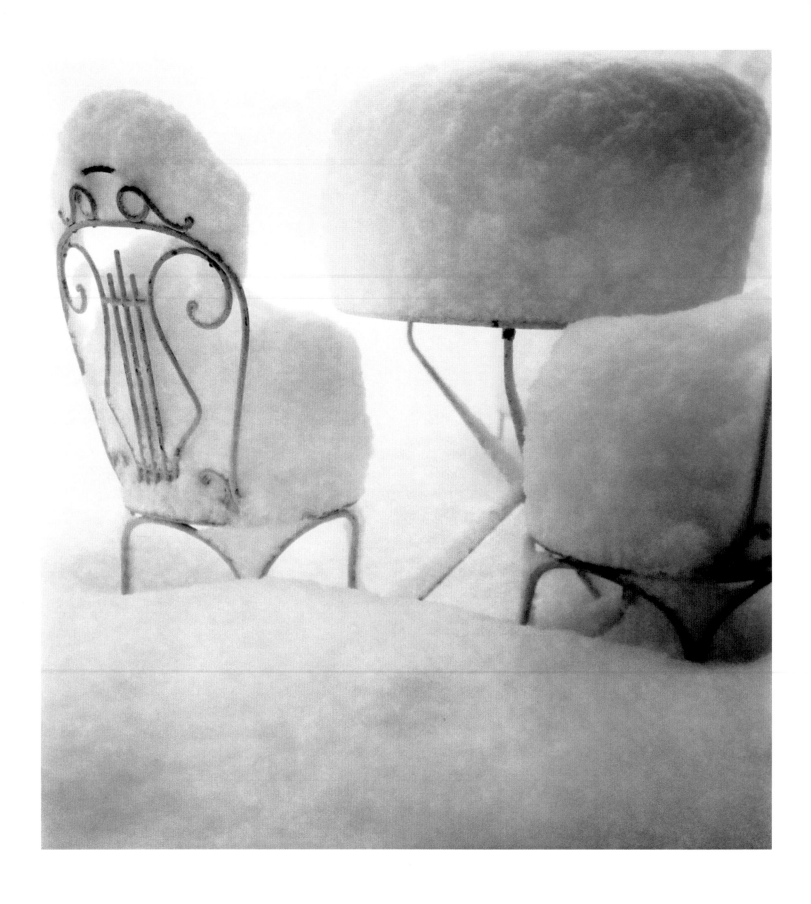

Snow at "Château-vert," Piscop, France, December 1945.

A silence
as soft as down

"Memories have no date, only a season."
Gaston Bachelard, *The Poetics of Reverie*

"The maturity of man—that means to have reacquired
the seriousness that one had as a child at play."
Friedrich Nietzsche, *Beyond Good and Evil*

It might have been six o'clock. It was pitch dark. A strange silence fell over his room. Staying still so as not to disturb it, the boy waited, eyes wide. Night seemed to drag on forever, stretching his patience thin. Sleep left him, and was replaced by plans for the day. He imperiously grabbed the corner of the curtain.

It was snowing.

In the light of the streetlamp, troops of snowflakes hurried, jostled, and overtook each other to be the first on the scene. Their obstinacy subdued the ground into total resignation, forming an all-encompassing shroud. As in the theater, the set-change had taken place in the dark.

The boy tore down the stairs, opened the garden door, and breathed in that raw air that cleanses the very soul. Then, with the determination of someone who conscientiously disobeys, he made tracks with his bare feet in the virgin snow to the first grove. On every twig, snowflakes were doing a miraculous balancing act.

Then he heard a voice, advice for the journey ahead: "In life, son, go where you please, but keep your extremities covered up: your head and feet!" The sound of the door had given him away. In the warm kitchen, a good fairy had heated up some milk. His frozen hands cupped the bowl of steaming hot chocolate; he watched the garden become reduced to a few geometric planes.

Galvanized by the spectacle of this metamorphosis, he felt that day that the snow was an inexhaustible gift. His step outside the usual bounds had taught him to see everything as if for the first time, to make his own tracks, to savor the delights of contrasts.

The snow lover

Lartigue's winter pictures evoke that indelible mark that a first snowfall leaves in the geology of every childhood. In a garden, a table records snowfall better than a nivometer could. Nearby, the lyre-like form of the chair echoes the silence. The image holds the promise

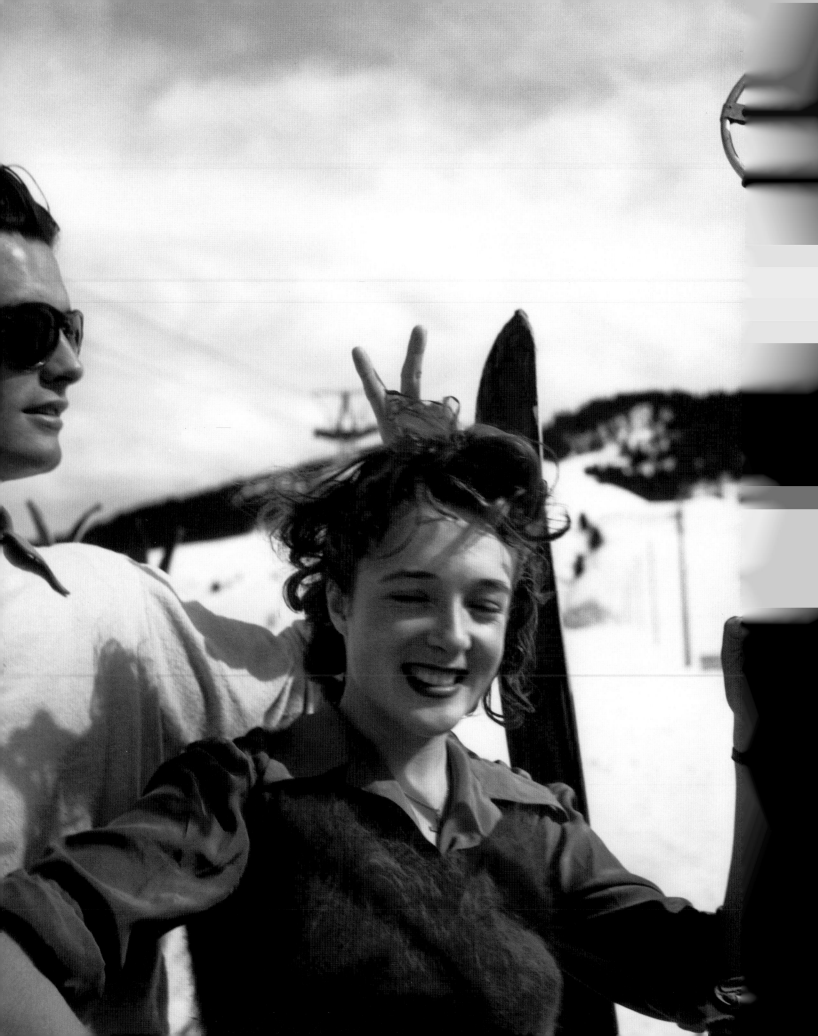

of Lartigue's vision. It contains as much emotion as snow—and invites us to share in his wonderment. So, like Lartigue, fascinated, we contemplate the heaping up of these little ephemeral masterpieces. Faced with such mysterious beauty, some seek to understand, others to create.

Much has been written about snow, this perfect hexagonal structure. As early as the sixteenth century, Olaus Magnus, archbishop of Uppsala, wrote a treatise on the graphic representation of the snow crystal. A host of disciplines have since pursued its study—climatology, meteorology, glaciology, nivology, linguistics— aided for the last 150 by photography. On January 15, 1885, Wilson Bentley took the first photograph of a snow crystal through a microscope. He took 1500 more, 200 of which he published in 1931 in *Snow Crystals*. But snow has not interested scientists alone. Poets, painters and photographers, and musicians have paid tribute to it in ballads, or visual "snow effects," and *winterreise*. All have been bewitched by its fragile charm and have attempted the impossible: to reveal a process that inexorably conceals everything.

Lartigue threw himself into this quest with the enthusiasm of an amateur. That first snow lay deeply embedded in his memory: snowflakes falling from the sky like words whispered to the soul, telling him always to keep his child's eye. Because for them everything is a game; and so, as all children do, he treated the game as the most serious thing in the world.

That distant snow had fallen in the city, soft and resigned, covering roofs and pavements, reducing the world to tracks, lines, trajectories, and perspectives. When the boy went to the park on snowy days, each tree became a gnome's hat and set the scene for a fairytale, a wonderland of games, images, journeys.

On January 20, 1913, the whole Lartigue family, complete with their new, American-designed wardrobe trunks, boarded the overnight train for Saint Moritz. Throughout his life, Jacques

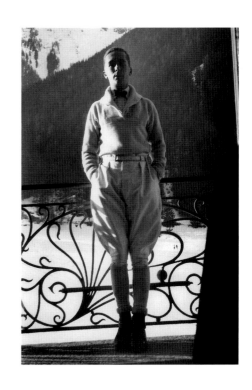

recorded his impressions and thoughts and the weather in a journal. He wrote: "I'm lying on a little *couchette* under a tiny rented blanket that smells of coal. It's not a nice smell but anything that smells of traveling is wonderful!"

During the night, he explored the compartment with the beam of his flashlight while outside the train's plume of smoke sliced through the landscape. In the morning, even the little jars of red and yellow jam in the restaurant car could not distract him from the window, whose frost he had scratched away with his fingernail. "Everything begins to appear in the dazzling light: a viaduct, mountains, snow, fir trees…"

When they arrived at midday it was snowing and Lartigue set foot "on ground lighter than the sky." The bells on the horses

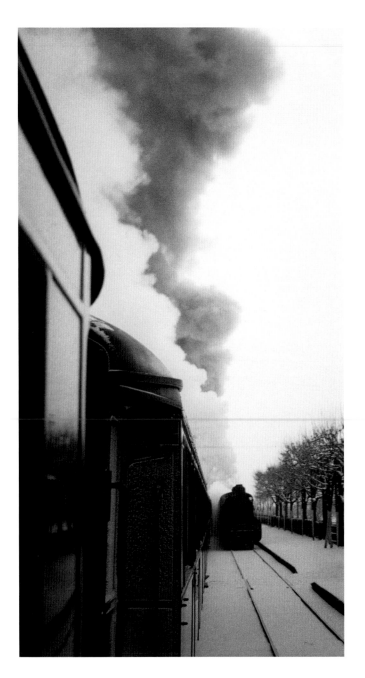

harnessed to their sledges hung in the air like notes of silence. "When I think that the other day I had such fun and found the landscape in the horrible little Bois de Saint-Cloud fairytale-like!" Mountain snow had swept away city snow.

From that moment on Lartigue shared the enthusiasm of the select few who, each winter, rather than hoping for snow in the grayness of the cities, left for the Alps. From 1913 to 1981, he went there about a dozen times.

"Every molecule of snow or ice is a real companion, cheerful, even-tempered, with whom you can chat and who always finds something nice to say to you." It was with these words, reflecting an entire outdoors ethic, that the director of the Sporting Club de France joined the efforts of the Club Alpin Français to promote the ski resorts that had sprang up in the French Alps since the eccentric Henri Duhamel had introduced skiing to France in around 1878.

Because his family was one of the wealthiest in France and among the most open to the new century's inventions (the first automobiles and airplanes had already won over the Lartigues), Jacques was able to take part in the rapid growth of "what is known as winter sports."

Saint Moritz was their first destination. The resort, lying at a height of 6089 feet (1856 meters) on the Engadine Express route, offered bracing air to an international jet-set. As early as the 1860s, the hotelier Johannes Badrutt was suggesting to English summer holidaymakers that they return in winter. He managed to convince them, and gradually the snowbound Bernina Alps began to fill up with Anglo-Saxons. They brought their favorite games with them, and in 1880 Saint Moritz hosted its first curling competition. (A century later, in 1996, it was again showed its innovative side when it held the first snowboarding cup.) The little resort in the Grisons launched the curling vogue in France, a sport described by its cross-channel adepts as "a very virile and very pleasant Scottish

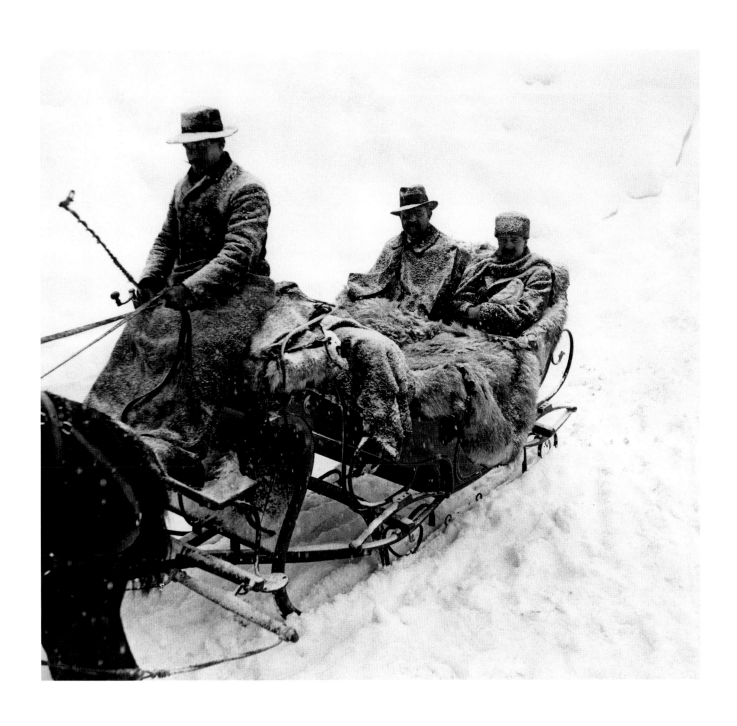

Papa and Plitt, Saint Moritz, Switzerland, January 1913. **9**

exercise that clears foggy brains, whips up the blood, and gives all those who practice it an excellent appetite." The sport's popular origins did not prevent it becoming a pastime of the sophisticated. The large hotels built ice rinks. Before the war, fifteen public and private rinks already dotted the resort, each with its own specialty: ice hockey, bandy, curling, figure skating, waltzes, speed skating, and so on, with some reserved for men and others for women. They were frequented by a cocktail of representatives from high society and the world of sport, each appreciating the company of the other. Lartigue met the Swedish champion Bror Meyer, who autographed a photo for him between lessons. The Frenchman Charles Sabouret taught Lartigue's cousin to skate, while Lartigue only had eyes for her: "There is something very mysterious between us." Lartigue was in love: with Simone, with the snow, with life.

"What is amusing here is that the wonderful holiday of the morning continues in the afternoon and the wonderful afternoon holiday carries on into the evening." In the silence of the snow, Lartigue flitted from one pleasure to another. For him, everything was a source of joy and discovery: sledding, bobsledding, skijoring. The lake at Saint Moritz was large enough to accommodate thoroughbreds, skiers, and gamblers. The English aviator Graham White, when he was not in an auto-bob, was one of the first to try the horse-drawn sport of skijoring. The only person to dress in black, he looked like "a negative of a ghost." Which could hardly be said of the filmmaker Max Linder and the Brazilian aeronaut Santos-Dumont, who sported clothes whose colors screamed out in the whiteness. Lartigue, armed with his Nettel 6 x 13 and his movie camera, was attracted by everything. He caught bobsled and skeleton adepts in action. The four bends in the Bobsleigh Run and the eight in the Cresta Run guaranteed falls and memorable photos. Saint Moritz became famous for these two runs, and a few others, as well as for its ski jump and many "snowfields," on which Lartigue learned to ski.

Sporting a tangerine sweater, a black cap with tangerine bobble, hunting pants, and thick boots, he donned his skis: "In Paris, people would think I was dressed up for Carnival, here no one gives me a second look." It only took a few steps on the two long narrow planks with turned-up ends for him to realize that "my two feet are rarely in agreement." He became philosophical: "Above all, one has to oblige the inside of one's head to become daring…. Ah, how much easier things would be if one didn't keep getting ideas!"

Further visits enabled Lartigue to work on his style. The Christiania turn, the Briançon stop, and the Telemark—that elegant turn that still inspires a few nostalgic adepts—soon held no secret for him. Not to mention his prowess on ice: loops, brackets, rockers, and counters also feature in the photo albums that Lartigue used to record the images of his life. But nothing could outshine the memory of his "little room that smelt of wood" when he woke in the morning "in a downy silence."

On both sides of the lens

Bedazzled by the snow and his discovery of "snow society," Lartigue extended the compass of his happiness. He discovered Chamonix, then only a tiny mountain village, and the Hôtel des Alpes. In front of the entrance were a snowman and large horse-drawn sleds. The dream continued: Jacques succumbed to the spell of whiteness far from the hail of iron and steel that was raining down on Europe. Too frail to take part in the war "for real," he offered his services as a driver, as well as his car (a Pic-Pic 16 HP), to transport the wounded and doctors from Parisian hospitals in 1916. In the meantime, with the grace of a snowflake that goes wherever the breeze of novelty takes it, he left to witness the beauty of the world.

In the snow, daily routine broke up like the ice on the Arve in spring. Once again, Lartigue threw himself into every winter game and sport, proving that winter is anything but a dead season.

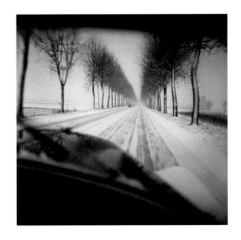

He met de Lesseps, the inventor of a propeller-driven sleigh and son of the diplomat who built the Suez Canal. Lartigue, freezing but proud to witness it, watched the machine reach 45 miles per hour. This was the age when technology had yet to disfigure the world and it still had a human dimension, when "genial amateurs" were not afraid to get their hands greasy. The pictures Lartigue took of them in the mist portrays them as half-demiurge, half-poet, and reminds us that the Greek *poiesis* means creation.

On both sides of the lens, Lartigue juggled the pleasures of the body and the image, whether still or cinematographic. Mesmerized by the snow, one foot above the other, he climbed slopes and crossed "the marvelous little frosted Pélérins forest." Hands frozen, lungs burning, short of breath because of the altitude, he discovered how exertion can flood the body. And then he would savor the midday stop. Winter evaporated. Steaming sweaters hung on the hot wood of a chalet set in a slope like a stone in a path. In a landscape of sugar and gold, he celebrated and savored the acoustic and olfactory with equal enthusiasm: a peal of bells, the blows of an ax, a dog barking after an explosion, resin oozing down fir trunks, donkey droppings. Drunk with the air and sun, he experienced melodious descents and explosive falls. And when he came across a pile of manure, his only concern was to immortalize the scene. During each stay, Lartigue recorded everything that his eyes beheld and his body felt, daringly blending body and photography, passing from one pleasure to another, never sad to forsake one because his enthusiasm had already been fired by the next. "One thing amuses me much more than trying to be graceful, and that is speed." He tried everything and, when tiredness overcame him, esthetic pleasure took over. The actor became spectator.

Making tracks across the snowfields, Lartigue caught moments and sequences with a very sure eye: eye and body were attuned. And professionals, seeing this, bought his films. "They pay me five francs a meter. But what pleases me even more is knowing I'll see them in the Pathé Newsreel…. Paris cinema audiences have no idea what it's like here."

In this winter-sport whirlwind, Lartigue transformed the slightest competition into choreography. His pictures, dictated by the senses, propel us between sky and land, into a ballet of gestures and trails. Skaters twirl, skiers jump, fir trees sway: it is all there, framed with the freedom of the happy amateur snapping a moment's physical and esthetic joy.

Lartigue was inspired by a whiteness that, like photography, both hides and reveals. He recorded these winter scenes as they happened, with an insatiable appetite: "I need four hands, four eyes." Movements, shadows, and light would dictate a horizontal or vertical composition, always thoughtful and delightful.

Figures gathered on the ice conjure up other images— Breughel's, for instance. A slope striated with stress, roofs like circumflex accents in the fields, viaducts straddling gorges, mountains transfixed by the frost-like crumpled sheets; everything was a springboard for his altitude-inspired imagination. Never the slightest heaviness; everything evaporated in lightness.

Overcome by the innocence of this dazzling whiteness, Lartigue swam in a silent, luminous happiness. The snow was his muse, but this did not prevent him from appreciating less ethereal ones: Germaine, Kiki, Minne, Mary, Jeanne Renouard…and, of course, his wife, Madeleine Messager, known as Bibi, daughter of the composer André Messager.

In 1920 the newlyweds left for Chamonix on their honeymoon: "the miracle of love is that I can be happy without needing to doing anything…. Around me, the high heels of her ostrich-feather slippers tap, turn, pass and pass again." Lartigue was now more preoccupied with Bibi's radiance than with the finer points of skiing which, in previous years, had held his rapt attention.

ABOVE *En route* from Paris to Toulon, France, January 27, 1954. **11**

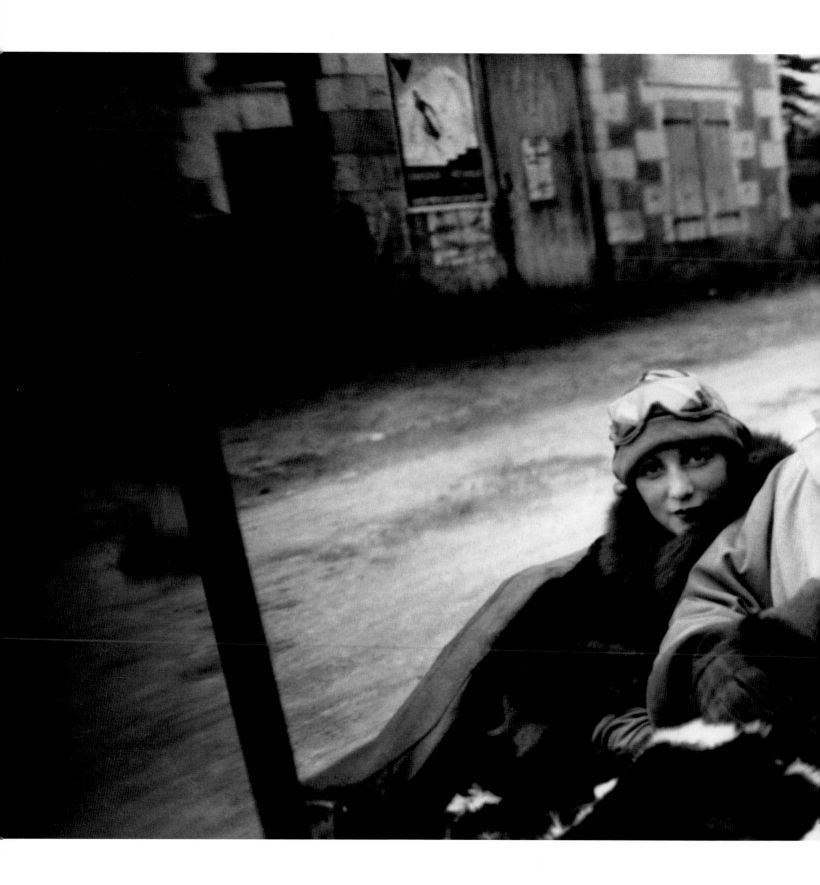

12 Bibi, Me, and Dédé, March 1926.

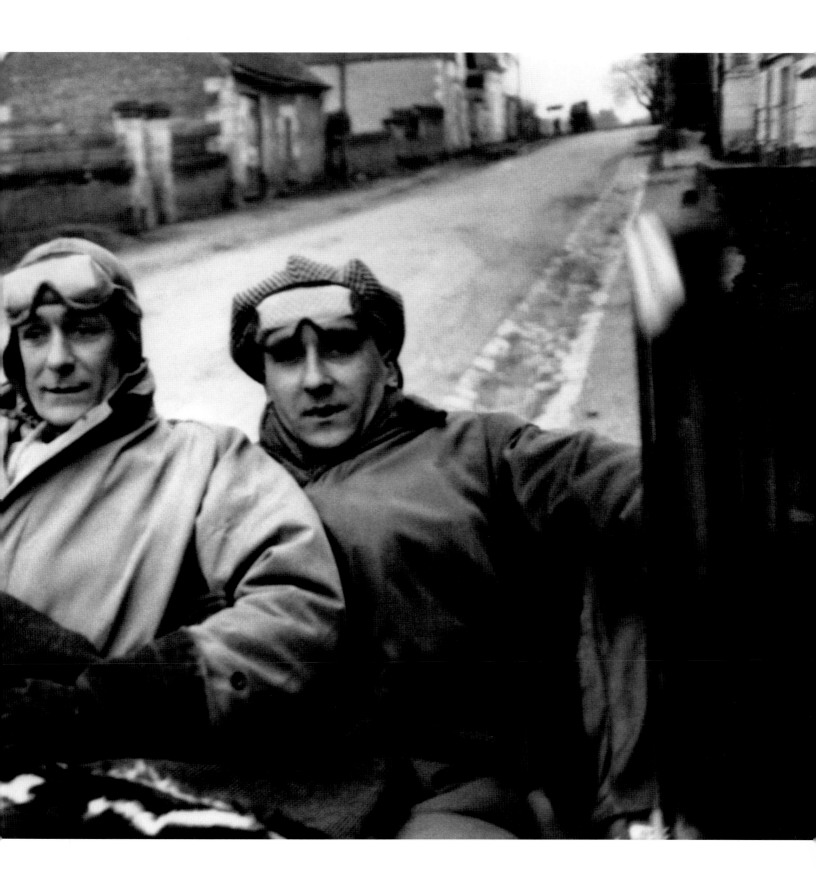

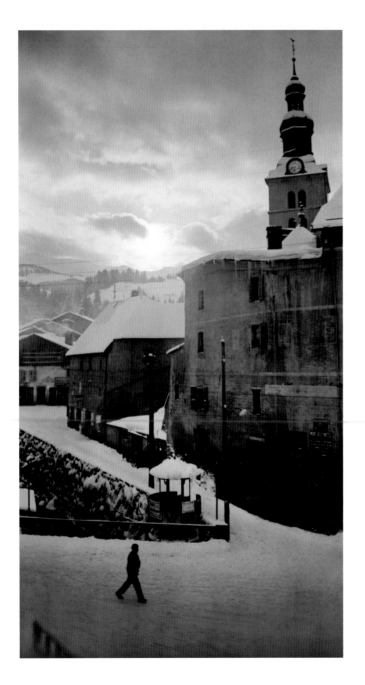

The snow that year seemed intimate, silky, melodious. "Happiness, like a tune, can be valued only by one's capacity to remember it." Interiors, streets, fashion plates, and a few snow scenes are the sole records of this interlude in Lartigue's more customary quest for moving images. He stayed wrapped up in his cocoon of happiness. "For them, ski, sled, and toboggan; for me, bed!" He lived each moment like a dream come true: "ice rink, patisserie, and all the little customs of little Chamonix," which had now become a high-society rendezvous and was equipping itself to cater to the ever-increasing number of winter-sports enthusiasts. There was now a train that traveled up to the foot of the Mer de Glace. Mule-drivers and farmers were trying to find a new place for themselves in a world no longer their own. Lartigue, taking advantage of this, had his photographic equipment carried by the mules; once in demand, now visitors no longer needed to use them. Certain hoteliers allowed themselves to become convinced of the need to install central heating. A statue of the Virgin Mary was erected on the summit of the Dru. Times changed, but not Lartigue's enthusiasm. He continued to explore the bridges between beauty and happiness. And when the winter snows began to melt, his mind turned to spring.

The delights of opposites

In addition to his family's affluence, wealth, and love, Lartigue was born with another heaven-sent gift, one which he paid back generously: the capacity to marvel at the spectacle of virgin nature, which is indispensable for an artist. The beauty of nature was for him the wellspring of his enthusiasm for living and seeing; for this reason, he never separated life and esthetic experience. If he saw a possible, latent image everywhere he looked, it was because he saw an underlying harmony in everything; and no doubt his feeling for beauty stemmed from this recognition. And despite the mandatory social events that punctuated his stays in these resorts, he never

neglected the overwhelming, silent spectacle of the snow. He took time out for this at Megève, where his ski hikes left him with "haunting memories of searing freedom […] Only those who have breathed in the sunny mountain air and experienced the elusive rewards of physical exertion can understand what I will not try to explain here." When he was lost for words, his pictures took over.

Lartigue returned to Megève several times in the 1930s. It was a more hospitable site, with nothing of the imposing austerity of Chamonix, even if Mont Blanc was still part of the scenery. There was a better view at Megève, its slopes were less forbidding, its activities more pastoral. In the center of the village, a sundial still measures out the rhythm of life of a bygone age. The sun did not light it after one o'clock in the afternoon because, as an old local told Lartigue: "One only needed to know the time in the morning, the villagers worked in the fields until sunset. No one hung around in the streets." The Latin maxim—*Plures labori dulcibus quaedam otiis* (many hours devoted to labor, a few to sweet idleness)—confirms this. With time the village became a winter resort.

In the 1920s, Megève, which had been launched before the war by the young sports journalist Mathilde Maige Lefournier with the support of Baroness Maurice de Rothschild, rapidly lost its original sporting spirit and became a society meeting spot, particularly after the opening of the Mont d'Arbois hotel. In 1933, the young Paul Morand worked as a bellhop in this prestigious establishment. The job was his father's idea; he wanted his son to break his habit of putting his hands in his pockets. The future author rubbed shoulders with some of the leading figures of the time and sharpened the sense of observation that would later resurface in his writing. The clientele left to go skiing on the Arbois plateau, rucksacks on their backs and sealskins on their skis. When it was time for a break, a few tangerines quenched their thirst, leaving a spot of color on the snowfields. The famous *Les Mandarines* ski run, the first to be equipped with a "string"—a forerunner of the ski tow (a sled pulled by a cable wound around a diesel-powered winch), was named after the fruit. France's first ski lift, the Rochebrune lift, followed in 1933.

Prominent figures frequented the resort: Albert I, King of Belgium, the Citroën and Michelin families, music-hall celebrities, and movie stars. In 1941, Lartigue traveled to the resort with Micheline Presle.

Lartigue enjoyed the company of his high-society entourage, but sensed that other pleasures awaited him higher up the mountain: "Our lunch on our backs, sealskins on our skis, we climbed up above the tree line." To gain those few extra meters for the descent, he took the Train Bleu, a small shuttle built by a garage owner, Alphonse Dubois, who had had the idea of converting Ford truck chassis into charabancs. The invention was "worthy of a scene out of a comic movie. Skis and their owners piled in any which way, inside, outside, even straddling the hood. In the freezing early morning air I leave to meet the colors of the sun. The landscape is metallic…a few peaks already lit up emerge from the shadows…. I climb and suffer…. Suddenly an indescribable light descends in a pool ahead of me. An unutterable joy envelops me when I enter this zone of sunlight."

The experience far surpassed mere physical exercise. With each step, powder snow flew up on either side of his skis like foam from beneath a ship's prow. Lartigue discovered, in a profusion of tactile sensations, that no quality can be felt without its opposite.

Snow is an incomparable guide for savoring this alliance of contrasts. Like a metronome, it ceaselessly sends back complementary revelations. Snowflakes are both flight and immobility, the intimate and the distant, hot and cold. Whether at Saint Moritz, Chamonix, or Megève, Lartigue never stopped exploring this paradoxical experience. The small daily encounters opened his eyes to the harmony of the world and allowed him to attain a more subtle level of consciousness.

Because he was so immersed in dazzling whiteness, he went into ecstasy at the sight of the blue of the night sky or "the minuscule green shoot of a plant whose name I do not yet know," or Bibi's blush, or a few yellow drops of urine "falling warm on the beautiful untouched layer [of snow]." His pictures and words, in turn lyrical and prosaic, have the precision of a haiku, addressing themselves to the body in order to better reach the soul.

"There should be a way of photographing noises!" he regretted. Yet his pictures, although silent, evoke even the slightest sound: the murmur of an iced-over waterfall, a church bell tolling out the hours, a bird chirping at the approach of spring, or Lartigue's steps crunching through the frost early one morning.

As for smells, they are all there, cocooned in whiteness: patisseries, the perfumes of beautiful skaters, mule's dung, shoe grease, and the most subtle and tenuous of them all, the smell of cold—the negative of a smell, Lartigue would have said—which contains all of these and conveys them to those people who can still remember their first sight of footsteps in fresh snow.

Lartigue spent winter savoring the possibilities snow offered for sporting exploits: in competitions "with large numbers pinned to sweaters," from which he left convinced "that sport is for other people, not for a string bean like me!", or in the solitude of ski climbs when all that counts is the sensation of breathing in the blue of the sky. Little bothered his numb fingers, his feet bruised by the straps holding his boots, aching knees, a cramp, and other miseries. Lartigue marveled: "Unsuspected, deep down inside me, there is a bottomless reserve of energy crying out for me to draw from it…. No wonder drug could replace the well-deserved joy that comes from physical effort or suffering."

Each passing hour shed new light on the art of living. Lartigue tried on all happiness's disguises, whether sporting or social: he wore ski suit, cameraman's outfit, dinner jacket in the salons of the Majestic; he was dressed up by Paul Poiret's sisters for the fancy-dress balls at the Savoy in Chamonix; he became a timeless gigolo in a "small dance hall lit like a fairytale cottage in the middle of the frozen night" in Megève, or a production stills photographer at Villard de Lans with Paul Emile Victor, Charles Vanel, and Michèle Morgan, who celebrated her nineteenth birthday during the filming of La Loi du Nord. Yet neither those "doll's eyes" nor society life could efface the simple, solitary joys that punctuated Lartigue's winter-sports holidays.

Winter in the mountains taught him that two opposite qualities only appear to be so; in fact they are two facets of one and the same reality, like two skaters—one black one white, yin and yang—intertwined in the same figure, becoming a single body.

With Lartigue's journal now closed, one anecdote lingers. No picture in his albums recorded it. No doubt the photographer knew that the things we see do not last, whereas what we cannot see is eternal. This moment, recorded in the intimacy of his journal, gives depth to a life that might be judged by some to have been futile. But this word can reveal something to us. It whispers to us the idea of flight, of movement, and because of that, music. One thinks of a fugue, for snowflakes and chimes.

Five o'clock in the morning, January 18, 1914: "in a rather moon-colored sky, slightly pink," Lartigue wanted to go alone to church to pray. "I saw last night how one opens the hotel's little door onto the street. I went downstairs, opened it and there I was out in the snow…. The air stunned me and all my present happiness danced in my head…. I had things to say to Almighty God." From snow to religion is but a short step, which Lartigue took at that hour when night bows out and the priest makes his first genuflection. He discovered a snow, which mediated between visible and invisible; the snow in which the alchemists thought they saw the soul of the world.

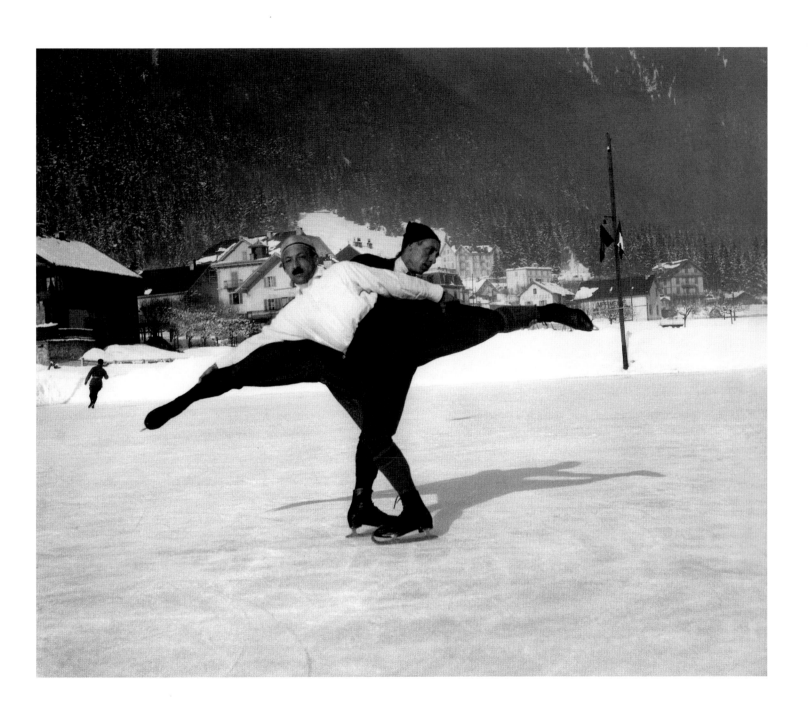

Pigueron and Heïdé, ice-skating championship, Chamonix, France, January 1919. **17**

"Snow, like the sea, is something one learns. I need time and perseverance for this and, I think, a superior motive, a certain cosmic curiosity," wrote Samivel*. Lartigue also wrote of his interest in this inexpressible substance that attracts and intrigues: "Only a blank page could say what cannot be told, cannot be painted, is not remembered: snow, sun, youth…" Whiteness, in a word. Emptiness to express fullness. Time to glimpse eternity.

Nostalgia surfaces. Falling snow recalls fallen snows. The weather inexorably evokes time passing. One only has to watch the landscape whitening to glimpse the past. Lartigue went to Megève for the last time in the 1980s. "No, it is not because an old man has poignant memories that he has the right to judge the village any differently than newcomers with virgin memories." He was harking back to a time when the snow was whiter because it was seen with "first-time" eyes. He had come full circle.

Of the four seasons, winter is the white-haired ancestor, the one that tells stories and brings back distant images. In Lartigue's pictures, people in a sleigh whitened by a snowstorm conjure up that ancestral snow and awaken the primeval time that sleeps in all of us. A house illuminates the night like a lighthouse and protects us; snow turns the slightest shelter into a cocoon for our fears, envelops us, festoons us, petrifies our most subtle states of mind, and ceaselessly urges us to take the step from the real to the imaginary—like a man's shadow on the snow, leaning, as though on the balustrade of an ocean liner.

Snow. The word and the thing itself set off vibrations that send us on many different journeys. All one needs is a few snowflakes to create a landscape in paint, or a few letters to transform snow into poetry: "Nothing but dreaming white," wrote Rimbaud. Snow, the word glides like a waltz, melts like a melody. Opens our eyes. Snow acts as a messenger of the invisible showing us a new and pure reality. The photographer and his subject meld.

With complete candor

Beyond being a pretext for creation and recreation, snow has its own life, one of breaths and silences and metamorphoses: incisive and still at night, soft and vaporous during the day, ceaselessly palpitating. A drifting snowflake seems to hesitate and change direction, seemingly by choice; to watch it fall, like clusters of fireflies, is to discover its luminosity. No doubt it comes flying to the aid of winter, so little visited by the sun.

The spectacle hypnotizes: suddenly one sees snowflakes levitating back to their origin. This enigma opens up a breach in which differences disappear, in which men, animals, trees, and all living creatures take their place in a metamorphosed world that both brings together and confuses. A world that knows that from time to time the sky pays a visit to the earth. The high and the low, the light and dark, are more than words. The time has come to wrap oneself up from head to toe. It is also time to look up at the clouds and question the "downy silence."

Bachelard suggests that "mythology is a primitive meteorology." Man shows great poetic invention when faced with the spectacle of snow; he assigns its origins to the moon and stars in turn, or sometimes to God and the saints: the people of Chamonix say snowflakes are Saint Joseph's wood shavings.

Like all myths, those involving snow give us images capable of reviving our desire to live in harmony with the elements. We need only a few crystals swirling in the air to rekindle our mythical awareness and to express our nostalgia for a lost unity. Snow speaks both to the senses and to the soul, weaves bridges between the physical and the metaphysical, and gives us moments of pure poetry. Man, watching snowflakes fluttering then losing themselves in all innocence into a unifying whiteness, takes stock of the mystery. He advances like a tightrope walker, the snow brushing his face, catching on his eyelids, opening his eyes. He feels the

need to become one with this moving unity, to vibrate with the slightest fluttering of nature, to glide in a constellation of suddenly enlarged boundaries. The experience is profound and, like all experiences involving beauty, it becomes cosmic.

The association of snow with feathers is used just about everywhere in the world to explain the origin of this intangible, airborne substance on the fringes between reality and dreams. Faced with all this whiteness, where can one turn one's eyes, where can one anchor a story? In the sky, of course, and among its inhabitants. From Japan to the Pyrenees, it is said that it snows when some genie is plucking geese. In the north, the fairy Hulda gets credit: she shakes her feather bed on snowy days. Lartigue's camera lens captures a wise, solitary duck traversing winter, seeming to affirm—with complete candor—that the legends are indeed true.

Élisabeth Foch

* Samivel, 1907–1992 (pseudonym borrowed from Charles Dickens) poet, traveler, mountaineer, script writer, author, painter, and illustrator who was particularly inspired by mountains. Publiications include: *The Summits of Samivel, Golden Iceland, Brown the Bear, François de France, The Glory of Egypt, The Glory of Greece.*

From 1902, Jacques Henri Lartigue began painstakingly
filling up large photo albums with his pictures, a daily discipline
that he would pursue until his death in 1986, filling 130
20.5 x 14-in (52 x 36-cm) albums with a record of his life—or at
least the one he wanted to leave of it. Cuts, reframings, erasures,
page layouts, dates, and annotations all convey his need
to compose these snapshots of his life, to shape what
he had captured on film until it reflected his experience.

The six album pages reproduced in this book (see pages
24–25, 40–41, 62–63, 84–85, 108–109, and 124–125)
are like windows opening onto Lartigue's winter world.

To keep these fleeting moments of happiness alive,
Lartigue also began keeping a journal. From 1911 to 1918,
in desk dairies (see pages 21, 22, and 23), he wrote notes
and made sketches daily, drawing from memory the framing
of each photograph he took, noting down his thoughts
on it and the weather. He continued doing this until his death
in 1986, recording fleeting impressions, reflections, joys and
feelings that were so mysterious to him he called them "things."

Lartigue's albums and journals were a dual, complementary
approach, through which he recorded a century of happiness.

9ʰ L. d. J. Je graisse mes skis – 10ʰ¼ Je pars av. Mᵐᵉ Piqueron
(en ski) ns allons à la gare, mais comme le train
à ¾ d'heure de retard, ns allons à la patinoire.
Ns y voyons de Martille, Masson, M et Mˡˡᵉ André, Plitt et etc.
Ns retournons à la gare – 11ʰ½ M. Bourgeois, Madeleine, Yvonne, Mˡˡᵉ Lelong
de Rauch et Robert George arrivent de Paris – Ns les accom-
pagnons à l'hôtel – Je vais à la patinoire – Ophélia, Marcelle
Bourlier, M et Mˡˡᵉ Richy, y sont – 12ʰ½ R – (ski).
12ʰ¾ déjeuner avec : M. Bourgeois, Madeleine, Yvonne, Mˡˡᵉ Piqueron
M et Mˡˡᵉ André, Ophélia, Marcelle et M. Bourlier, Plitt, de Rauch
George et Mˡˡᵉ Georgette Lelong. 1½ Je vais avec Mᵐᵉ Piqueron,
Ophélia et Marcelle Bourlier (en ski) à la patinoire
Ns faisons q.q. photos – De Rauch m'apprend un peu
à jouer au hockey sur glace !! Je vais en ski avec
Mᵐᵉ Piqueron, Ophélia, Marcelle Bourlier et Yvonne Bourgeois
Ns allons faire des descentes au dessus de la patinoire
pour apprendre à Marcelle et à Ophélia – Ns rencontrons
M et Mᵐᵉ Richy – Ns faisons plusieurs descentes – 4ʰ½ ns
allons à la pâtisserie où ns goûtons avec M. Bourgeois, Madeleine
de Rauch, George et Mˡˡᵉ Lelong – 5ʰ ns rentrons à l'hôtel –
Je marque – (J'ai rencontré Rico !! il est arrivé ici de
Neuchâtel hier soir – il n'est pas au même hôtel que nous)
Je m'habille (smok.) – 7ʰ½ dîner (M et Mᵐᵉ Piqueron etc etc) – Ns allons
dans le salon – Je fais connaissance de M. de Lesseps – On danse
10ʰ¼ C.

ophélia Marcelle Mᵐᵉ Piqueron Didi Yvonne Mᵐᵉ Piqueron moi ophélia
63 Madeleine moi Mᵃᵈ

8ʰ½ L.T.d. Je prépare le cinéma. 10ʰ Je vais sur la route avec Plitt
où j'ai rendez-vous av. M. de Lesseps – Il arrive avec son
traîneau à hélice aérienne (mot. 60 H.P.). Ns allons installer
le cinéma et je le prends en vitesse – Après Plitt ns
prend de près dans le traîneau – De Lesseps m'emmène
dans son traîneau jusqu'aux Bossons – Nous faisons
du 70 à l'heure – c'est épatant, mais le vent est
froid !! Ns rentrons le cinéma dans le traîneau –
12ʰ Je charge – 12ʰ½ déj. avec M et Mᵐᵉ Piqueron, M. Bourgeois, Madeleine
Yvonne, M et Mᵐᵉ André, Ophélia, Marcelle et M. Bourlier, George,
Mˡˡᵉ Lelong, M. Adelberg. De Rauch et Plitt – 1½ ns partons
tous – Piqueron, Didi et George en ski – Mᵐᵉ Piqueron et moi
en ski-jöering et les autres en traîneau et en tailing –
Ns allons aux Praz – J'installe le cinéma – et Plitt tourne –
Ns faisons des descentes en skis – les uns après les autres
(il y en a beaucoup qui tombent) Ns descendons (Madeleine, Didi
Mᵐᵉ Piqueron, moi – Poisson, Berg etc) en ns tenant par la
main – Piqueron et George arrivent du haut et font
la descente à toute vitesse et, tombent et cassent chacun
un ski !! Ns faisons plusieurs bonnes descentes – 4ʰ½ ns
rentrons – Piqueron, George et moi en ski-jöering – Je vais
à la patinoire avec Mᵐᵉ Piqueron, Madeleine et Didi – Ns y
voy. Martille, Magnus, Masson etc etc – Ns allons à la pâtisserie
où ns goûtons : Piqueron, Ophélia, Marcelle, George, Taylor (qui est
arrivé ce matin) et etc vraiment – Je vois aussi Rico, Magnus etc etc
5ʰ R. Je décharge le cinéma – Je m'habille – Je téléph. à Pathé-
7ʰ dîner (comme au déjeuner) Je fais l'envoi des films à
Pathé et je leur écris – Je marque – Berg. André etc me donnent
des renseignements pour prendre les hôtes en cinéma demain – 10ʰ½ C.
Rico, Taylor et Magnus viennent nous voir (de l'hôtel Couttet)

de Lesseps moi Plitt Madeleine, Mᵐᵉ Piqueron, Berg, Kiki, Poison
68

Neige le matin (−6° à −15°)
T. Beau à partir de 11ʰ

T.T. Beau
(−5° à −14°)

JANVIER
JANVIER

18 DIMANCHE. Ch. de S. P. à R. 18-347
19 LUNDI. S. Sulpice 19-346

6ʰ L.T. 7ʰ Je vais à la messe - 7½ déj - J'écris à Mamie à 9ᵐᵃ à Sim et j'envoie des cartes-post - 10½ Je pars avec un mulet qui me traîne le cinéma - Ns montons au virage des Chauderons J'installe le cinéma - Je vois Plitt, Rico, Percepied, André, Berg et Je fais des photos d'arbres couverts de neige - 12ʰ la course de bobs commence - Je le prends en cinéma - Je prends aussi l'équipe de Berg, André etc. vu de près - Ns voy. un bob se retourner - C'est Berg Qui gagne la course (1ᵉʳᵉ manche de la coupe du Pⁿᵗ de la République) - 12½ Je redescends avec Plitt sur le traineau du cinéma - 12¾ déj. avec M. Mᵐᵉ Bourgeois, Madeleine, Suz. et Yvonne, Germaine et Francis, M et Mᵐᵉ André, George, Adélbert, Mᵉˡˡᵉ Lelong, Didi, et Plitt. 1¾ ns partons et ns allons (en ski) à la patinoire - J'emporte le cinéma Ns assistons au champ. de France de hockey (Club de patineurs de Paris (avec Didi comme capt. avec Taylor, George, masson, Lacroix etc -) contre club de Chamonix). Les Parisiens gagnent de 13 à 0. Taylor joue épatamment - Je prends du cinéma pendant la partie et ils viennent tous après la partie pour que je les prennes de près - 4ʰ Je pars en ski avec germaine, Francis, Yvonne Adélbert et Plitt. Ns allons dans les bois jusqu'à la piste de bobs et de là ns descendons - Ns rentrons à l'hôtel et Je vais à la pâtisserie avec germaine et Francis - Ns y retrouvons tout le monde - Je me mets du club des patineurs avec Francis et Didi comme parrains - Je vais chercher mes photos et le cinéma à la patinoire et je rentre - Je m'habille (smock) J'envoie les films à Pathé. 7½ dîner (comme au déj.) Ns allons au salon - on chante etc - 11½ C

66 moi

9½ L.d.T. Je marque - 10½ Je pars en ski en même temps que Mᵉˡ Lelong et Plitt - Je monte jusqu'au départ des bobs J'y retrouve Francis, Adélbert et les Richy - Ns voy. la 2ᵐᵉ manche de la coupe du Pⁿᵗ de la Rep - C'est Berg, André etc qui gagnent définitivement - Ns redescendons au virage des Chauderons et ns voy. une autre course - Ns redescendons à l'arrivée - Un bob rentre dans la barrière à l'arrivée Recopé est un peu blessé - 12¾ ns rentrons - déj. (comme hier). 2ʰ ns allons à la patinoire (Francis, germaine, les Bourgeois, Didi George, les André, Plitt, Lacroix etc et moi). Il y a une exhibition de patinage en l'honneur d'un ministre - C'est d'abord un match de hockey - et après Yvonne et george, Ophelia et Magnus et Francis seul font une exhibition - Ns patinons un peu et ns allons à la pâtisserie où ns voy. tout le monde. 5½ R. Je m'habille (smock). Je marque - 7½ diner (comme hier) Je joue à un jeux de cartes aux enchères (dans la salle à manger) avec germaine, Francis, Madeleine, Didi et Adélbert (c'est très amusant) ns ns amusons et ns allons ns coucher (11¼).

62

9ʰ L.T.d. 10½ Je pars en skis avec Germaine, Francis, Yvonne
et Aldebert - Ns traversons des bois couverts de neige (ravissants)
Ns allons jusqu'aux Bossons en passant par les Pèlerins
Ns faisons une descente de au moins 1 Kil. 12ʰ ns arrivons -
Ns allons boire un peu - 12½ ns prenons le train que ns
ramène à Chamonix - 1ʰ déjeuner - 1¾ Je vais avec
Ophélia, Marcelle et Plitt à la piste de luge - Ns la
descendons et ns allons à la patinoire où ns retrouvons
Francis, Germaine, les Bourgeois, les Richy etc - Ns assistons
au match de hockey France c. Bohème - Didi, Taylor,
George et les autres jouent bien - Ils font match
nul avec 1 point à - Ns patinons un peu - et ns
rentrons à l'hôtel - Je pars en skis avec Francis
+ Plitt et Mᵉˡˡᵉ Lelong - Ns montons jusqu'aux Chardons
Je fais de bonnes descentes avec Francis - Ns allons du côté
de la piste de luges - Ns rencontrons Aldebert - Ns descendons
et ns allons à la pâtisserie où ns goûtons avec Germaine, Maddi
Suzanne, Didi, Yvonne, Ophélia, Marcelle etc - Ns voy. tout
le monde - Ils chantent - 5½ ns rentrons - Je mange et.
7½ dîner (comme hier) - Ns allons tous (sauf Madeleine, Ophélia
et Marcelle) à la patinoire - Ns faisons des bêtises sur la
glace sans patin - 10½ ns allons (Germaine, Francis, Plitt,
et Mᵐᵉ charpe, George, Kiki, Berg, et 2 ou 3 autres) manger de
la fondue dans un p.ᵗ restaurant - Ns ns tordons, on
s'étrangle - Au moment où ns sortons, ns voy. Zanferese
à la fenêtre de l'hôtel Contet, ns lui lançons des boules
de neige - Taylor ns jette de l'eau de la fenêtre au
dessus - Ns rentrons à l'hôtel et ns reveillons (en chantant
devant leurs fenêtres) André, Suzanne, Ophélia et Marcelle -
1½ C.

9ʰ L.T.d. 10ʰ départ avec: mon cinéma, 2 cinémas gaumont, un photog.
et 4 traineaux (avec Francis, germaine, Madeleine, Suz. Yvonne, Didi,
Plitt, André, Berg, M et Mᵐᵉ - et d'autres) - Ns allons aux pèlerins
(en tailing) Je prends du cinéma et des photos en couleurs de
nous en ski - on nous prend en cinéma gaumont en ski
et en ski-jöring derrière les traineaux - (en cinéma noir et
en couleur) - 12½ les traineaux rentrent - Il y a un mal entendu
et je suis forcé de rentrer en ski et Plitt aussi - Je confie mon cinéma
à l'op. de gaumont - 1ʰ déj- (comme hier) - 2ʰ Je vais à la patinoire
avec Marcelle, Ophélia etc - Nz y retrouvons tout le monde -
Ns assistons au match de hockey France c. Angleterre
Les Anglais gagnent de 3 à 0. Didi, George, Taylor jouent bien -
Je rentre à l'hôtel avec Didi et Madeleine - J'écris et j'essaie
de téléph. à Pathé - 4½ ns allons (Didi, Madeleine et moi) à la
pâtisserie où ns retrouvons Francis, germaine, M. Mᵐᵉ Bourgeois, Yvonne
Suz. Marcelle, Ophélia et ns voy. Rico, etc etc. - Goûter (thé)
Je vais chez le photog. avec Didi et Mad. 5½ R. Je téléph. à
Pathé - Il ne me prend probablement pas les films du
hockey, ni des bobs - peut-être celui du traineau de de Lesseps -
Il me dit d'en reprendre d'autres - Je charge le cinéma -
Je mange - 7½ Germaine, Francis, Berg, Aldebert, M et Mᵐᵉ Maréchal
Kiki et d'autres se déguisent et vont en dîner costumé - Ils
sont tordants (surtout Francis en clown, germaine en bébé et Kiki en poupée)
Je les photo. au magnésium - 8ʰ dîner (sans germaine, Francis ni
Aldebert) - Ns allons au salon - Je fais des dessins avec Madeleine et Didi
11ʰ Francis, germaine et les autres rentrent - 11½ C.

Didi, Madeleine, Germaine, Francis, Mᵉˡˡᵉ Lelong, André, Berg
Aldebert, Mᵉˡˡᵉ Lelong
Maréchal, Mᵐᵉ Maréchal, Berg, Chardon
On nous cinématographie
Les 2 cinémas gaumont
Pétel, mon cinéma
Germaine, André, Francis

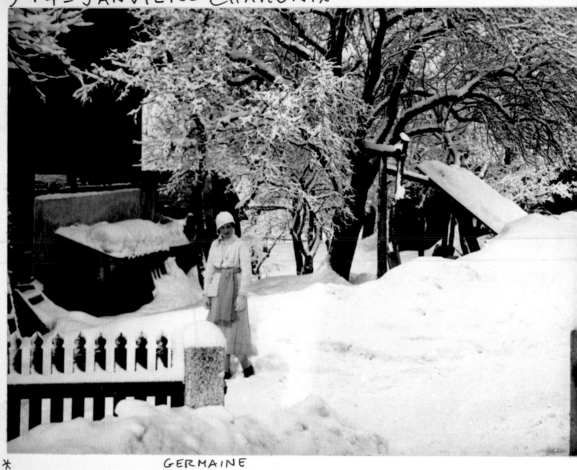

* GERMAINE

FRANCIS PIGUERON

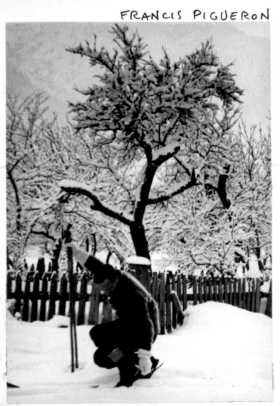

*

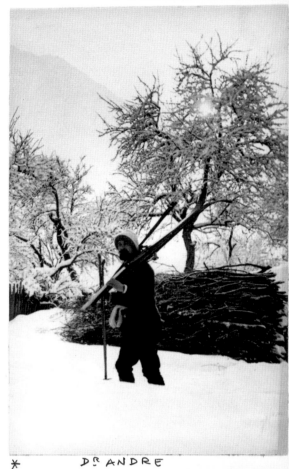

* Dʳ ANDRE

GERMAINE — MOI

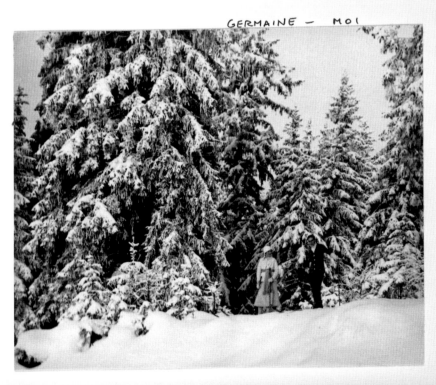

"Everything begins to appear in the dazzling light..."

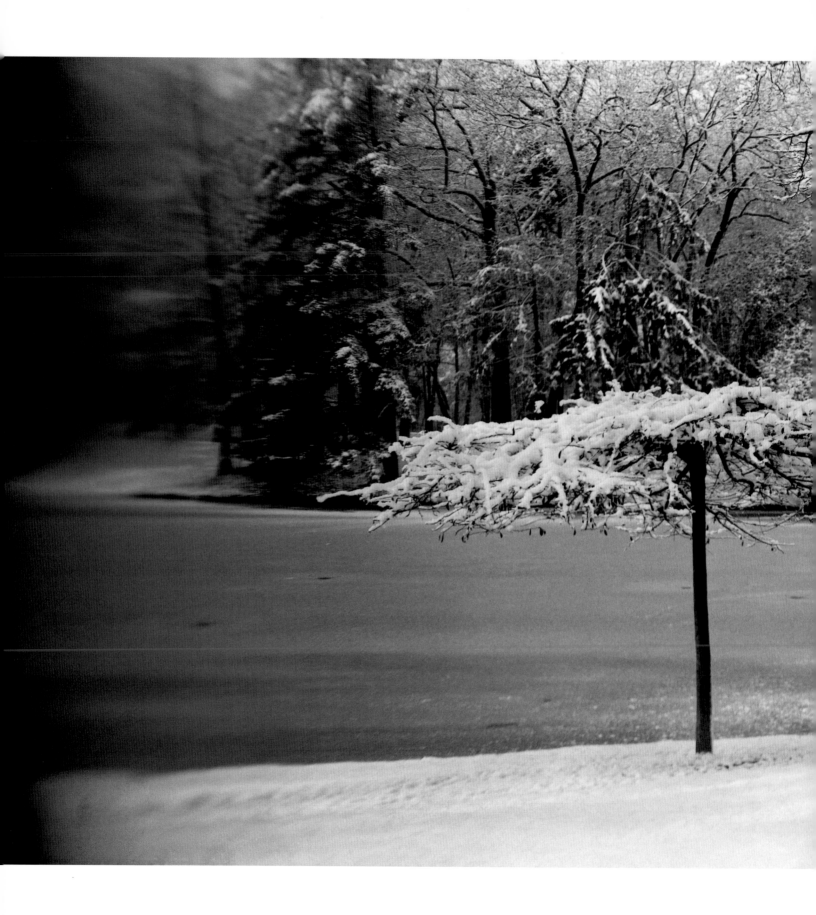

26 Snow in the Bois de Boulogne: three swans on the frozen lake, Paris, December 1925.

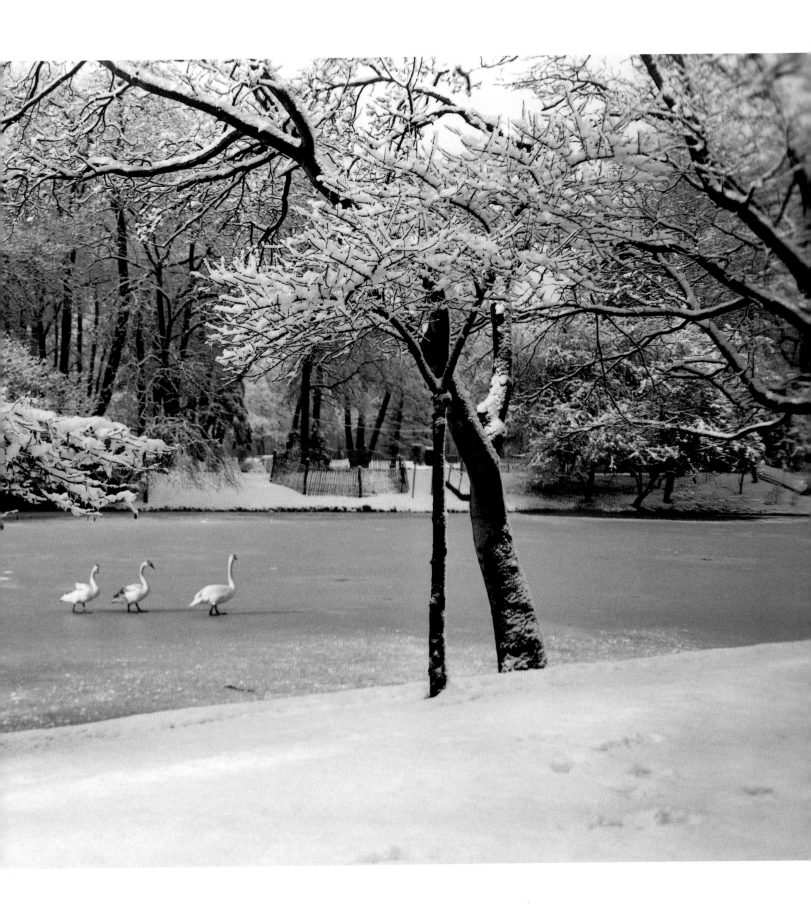

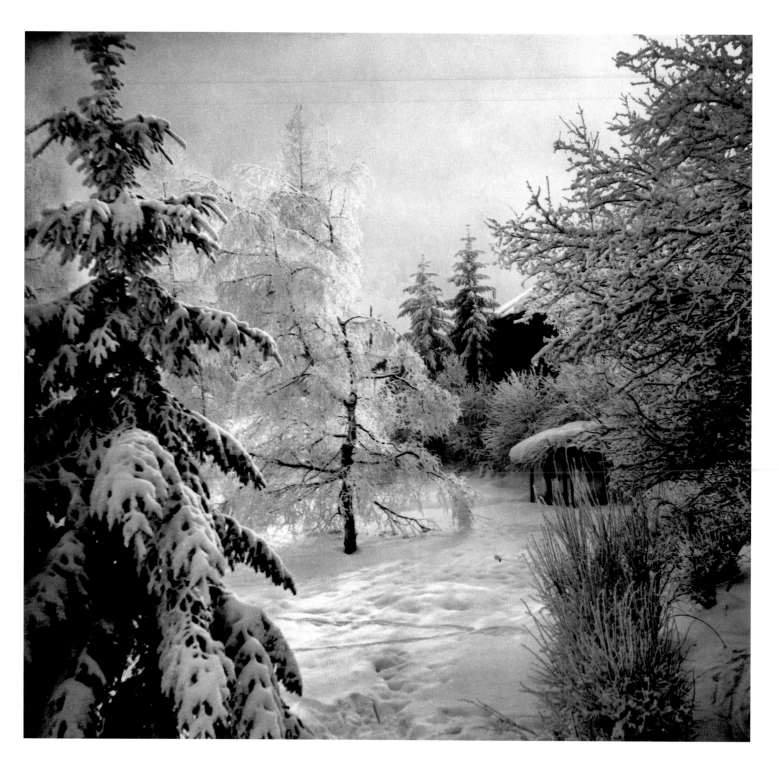

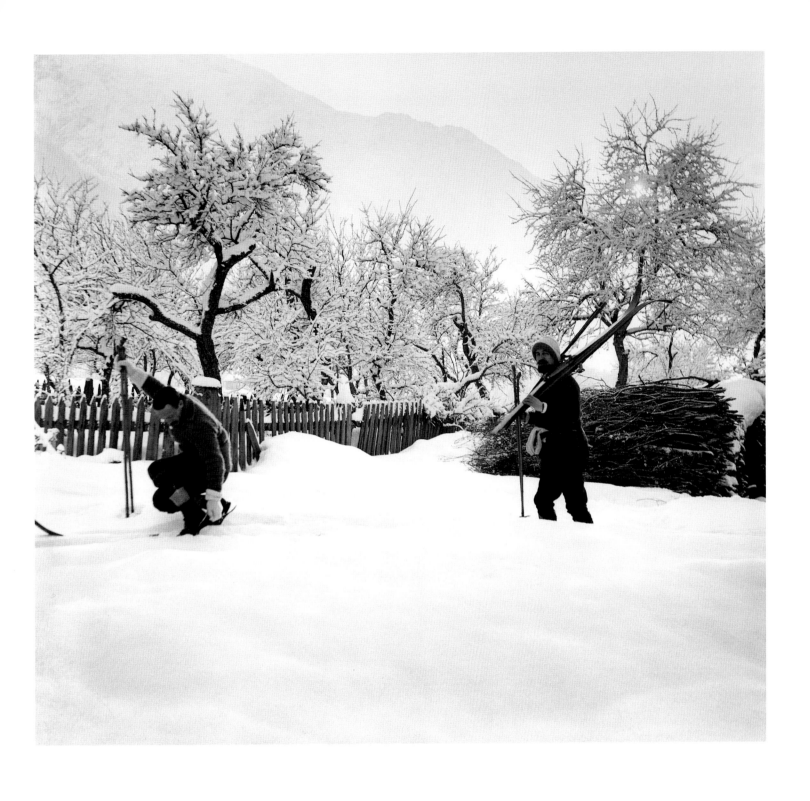

ABOVE Doctor André, Chamonix, France, January 1914.

FACING PAGE Chamonix, France, January 1914. **29**

"…There are trees that are so extraordinary and marvelous with all their branches coated with snow that I stop filming, forsake the bobsleigh race and go and take photos. Everything is snowbound and the sun that has come up over the mountain lights everything; everything shines, sparkles, and dazzles, and it's an extraordinary fairyland and the sun warms my back as I take my photos, and it's a bit like last year on the portside at Monaco when I was photographing the dinghy racing: a mixture of amusement and happiness…"

Chamonix, France, January 18, 1914

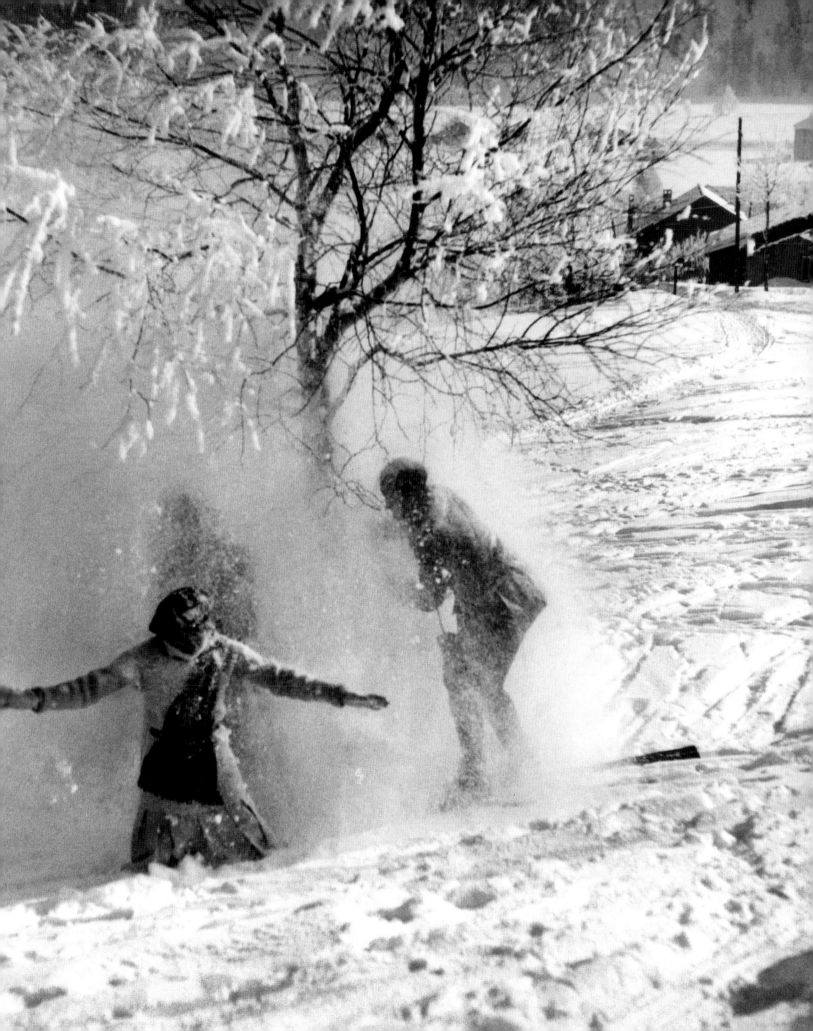

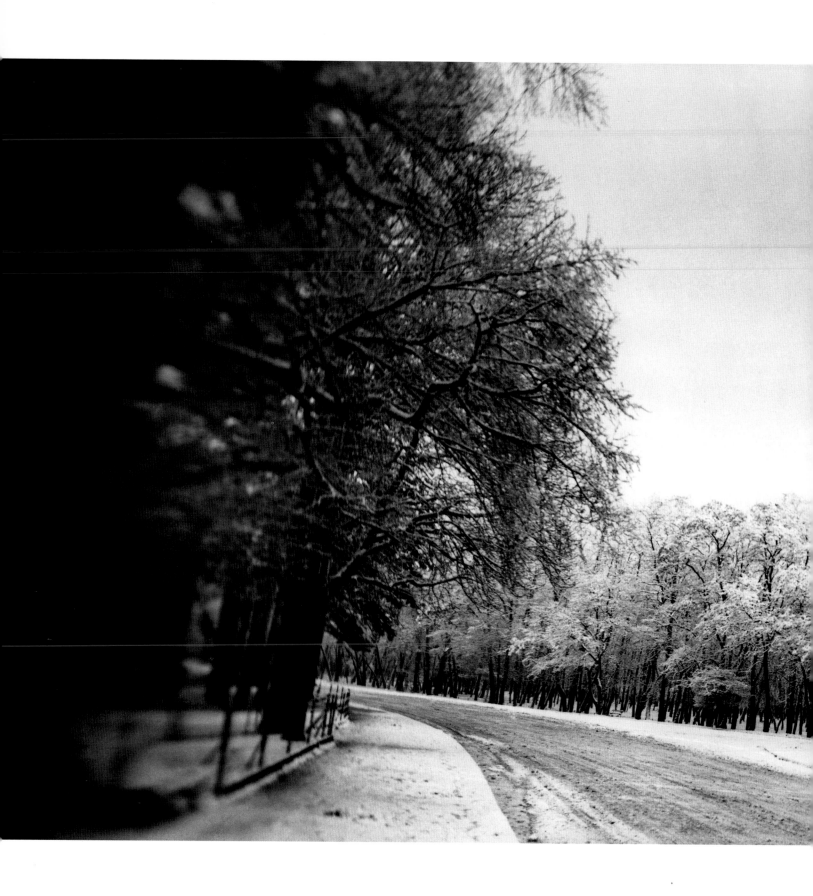

Snow in the Bois de Boulogne, Paris, December 1925.

FOLLOWING DOUBLE PAGE: LEFT Snow in the Bois de Boulogne, Paris, December 1925. RIGHT Bibi and Daisy at the Boucarts', Robinson, France, January 1929.

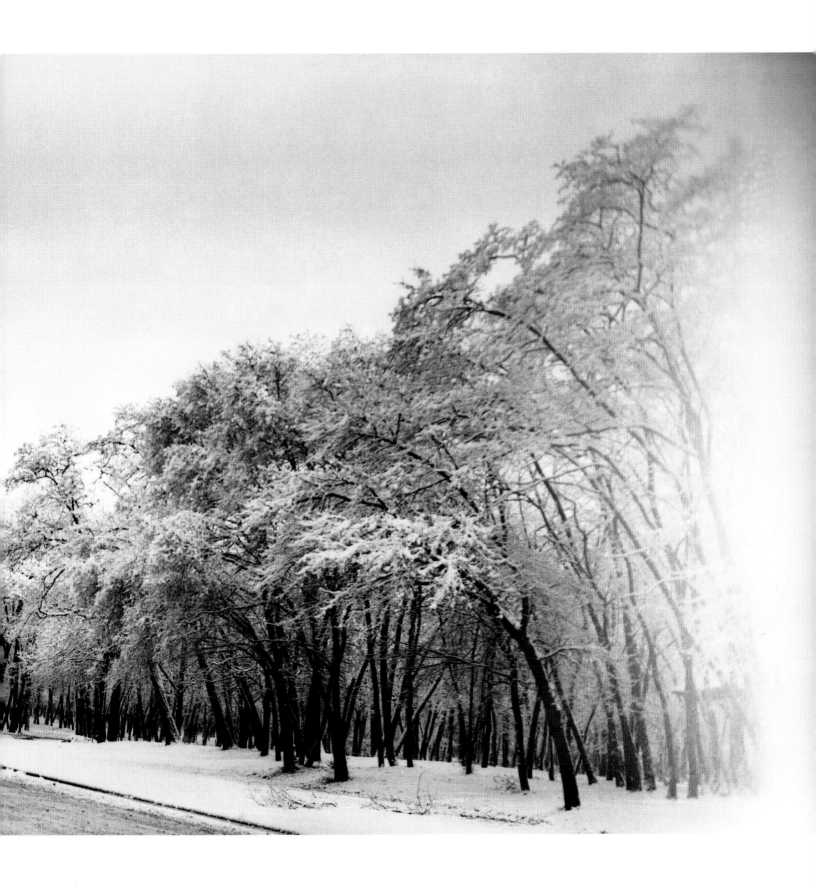

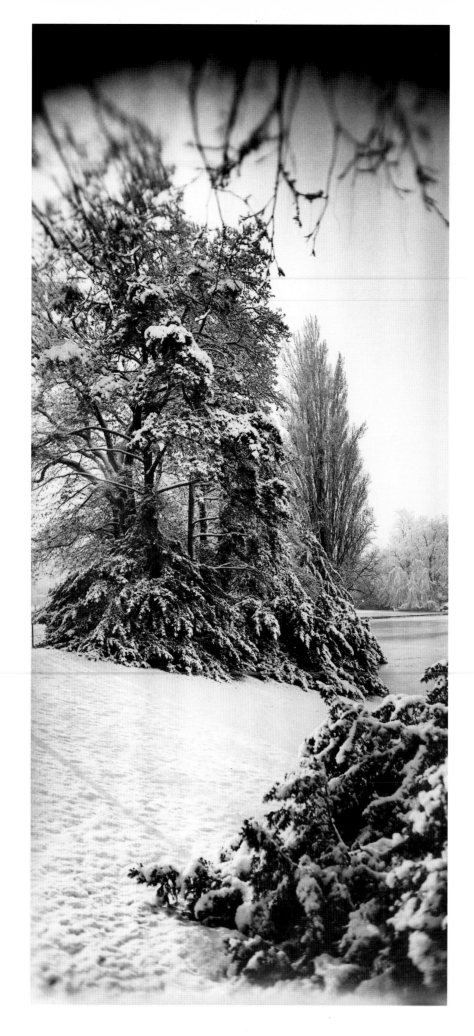

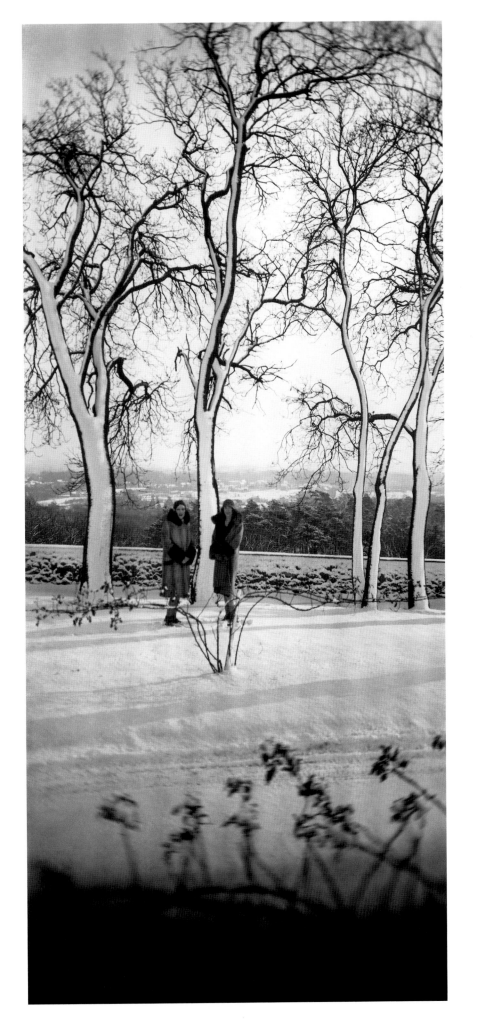

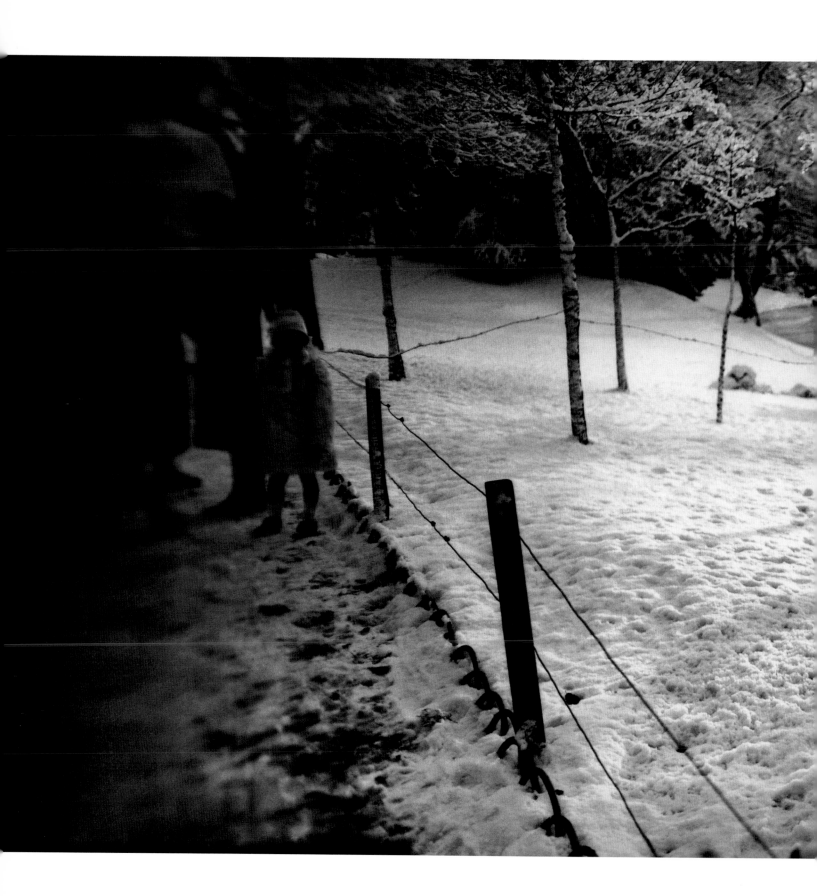

36 Dani by the lake in the Bois de Boulogne, Paris, December 1925.

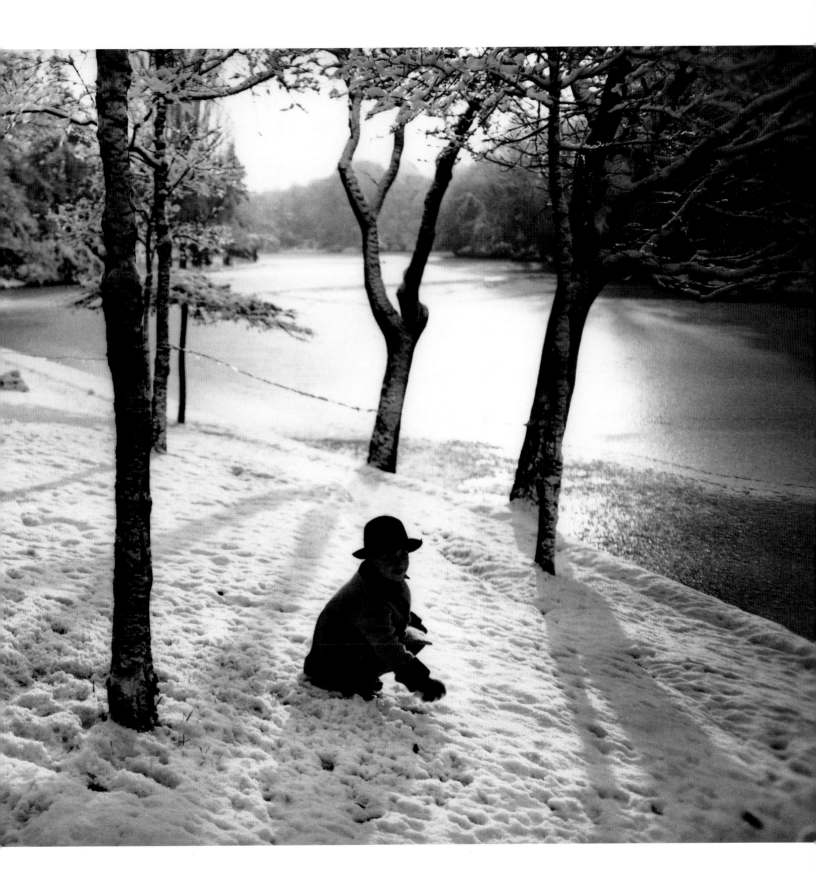

"It's snowing and the slopes dissolve in a dazzle
of colorless light. The colorless color of the sun is
everywhere and my skis are sliding over sky.
I am in the negative of night. Everything is light
yet there is nothing to see…"

Chamonix, France, January 10, 1920

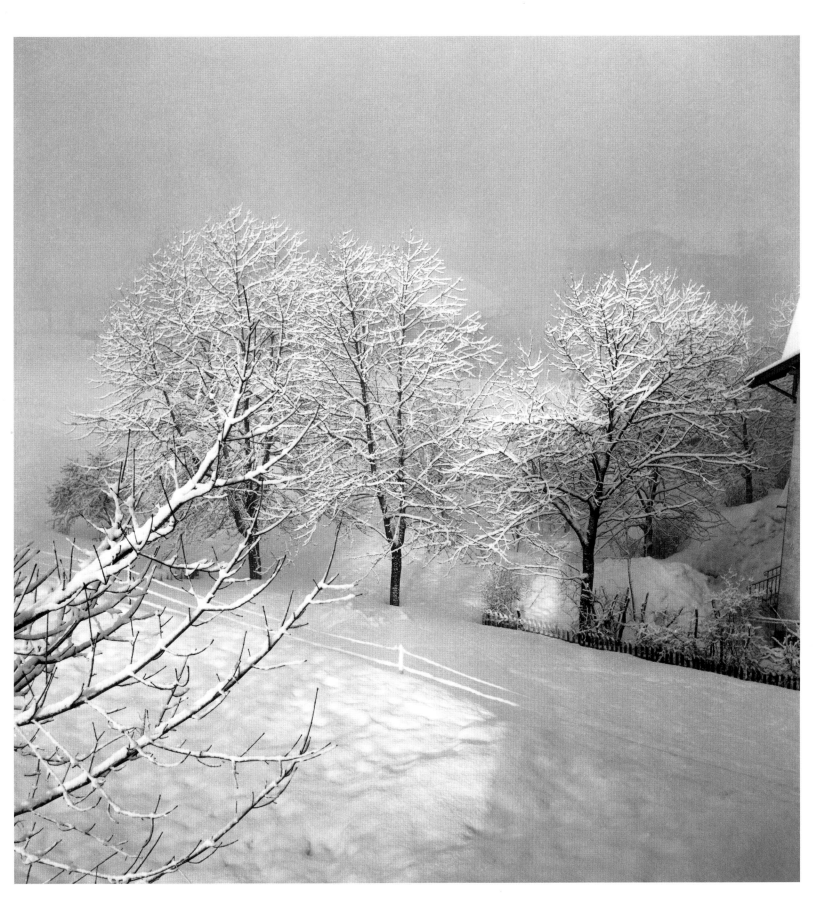

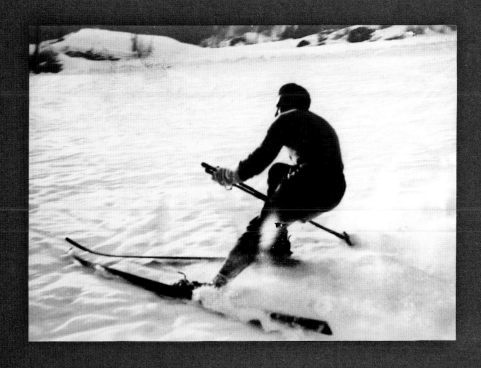

JEAN

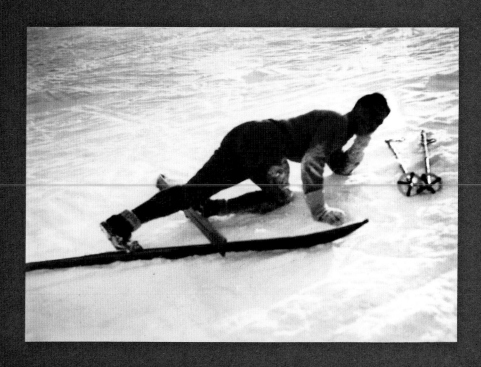

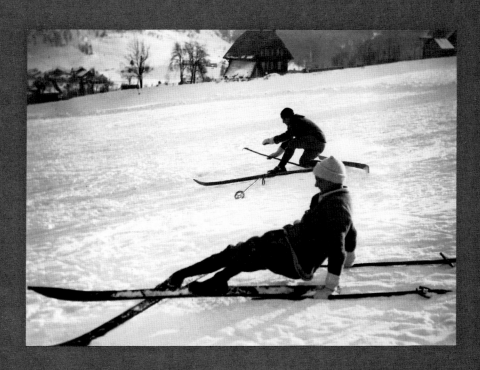

FASQUELLE
HENNESSY

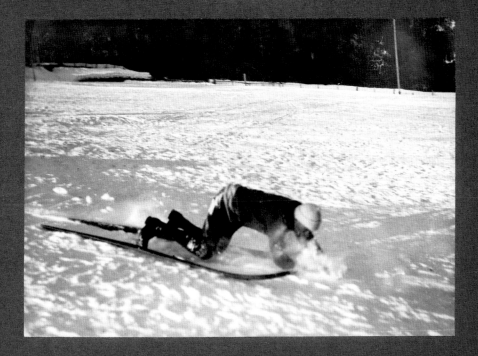

"Giddy with air, well-being, and love..."

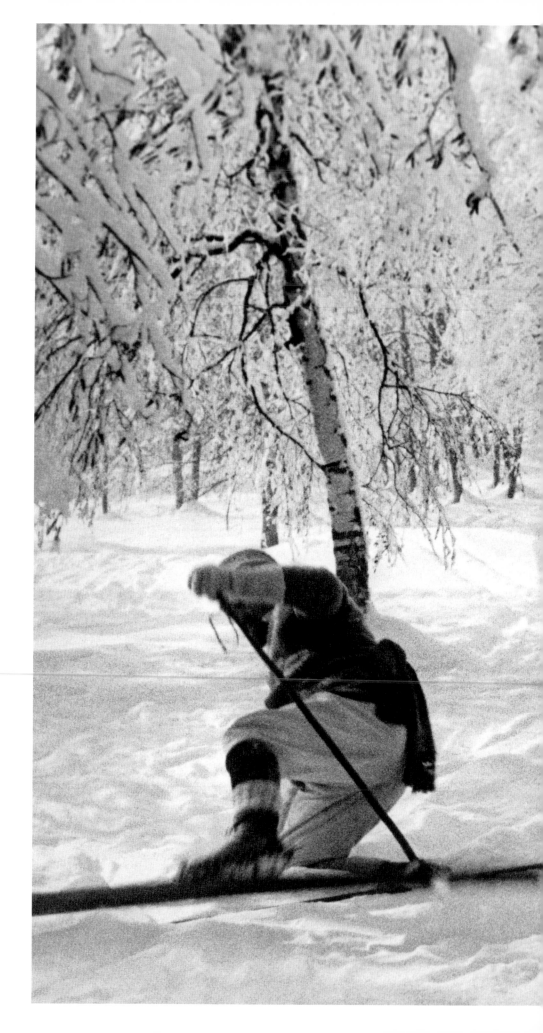

Still from *Mon cinéma*, filmed by Plitt,
Chamonix, France, January 1914.

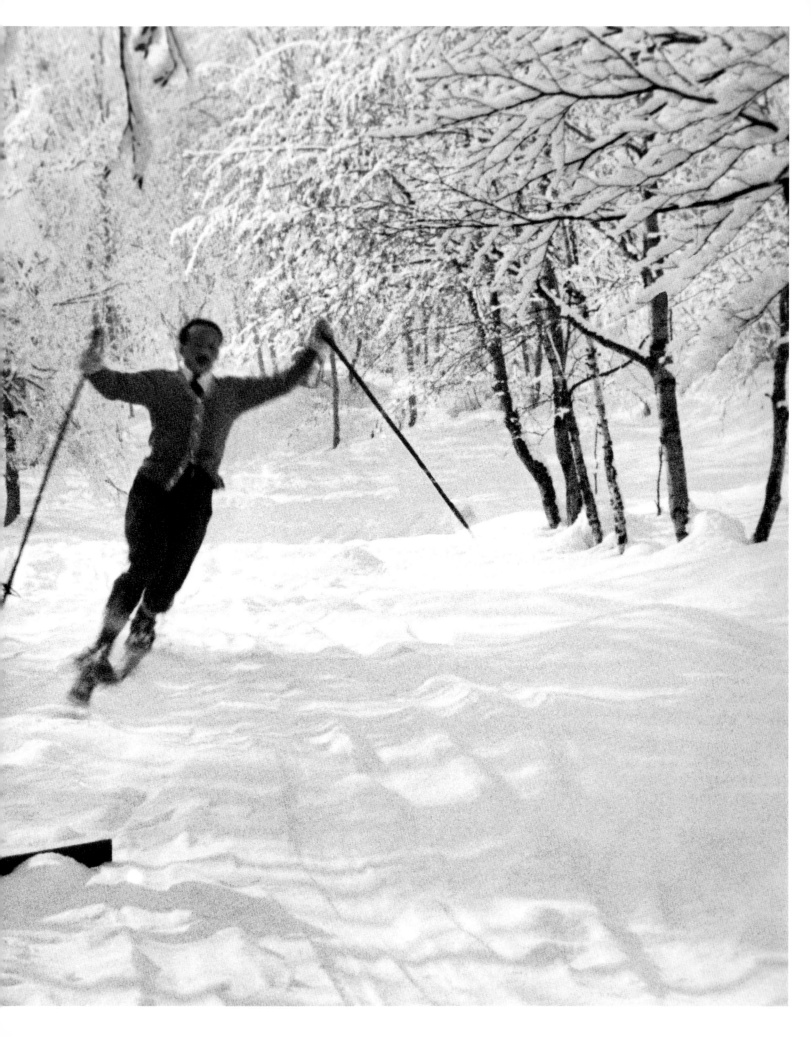

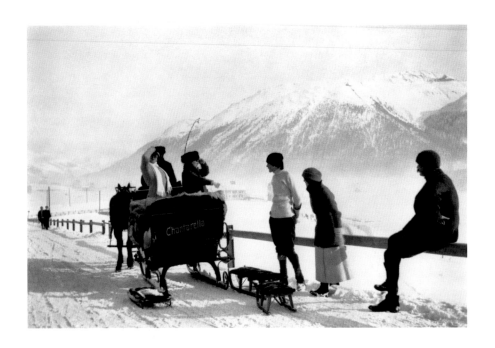

ABOVE Mme. Folletête, mother, me, Simone, and Mr. Folletête ('Plitt'), Saint Moritz, Switzerland, January 1913.

RIGHT Pigueron, Garon, Didi, Charavel, and Rico, Chamonix, France, January 1920.

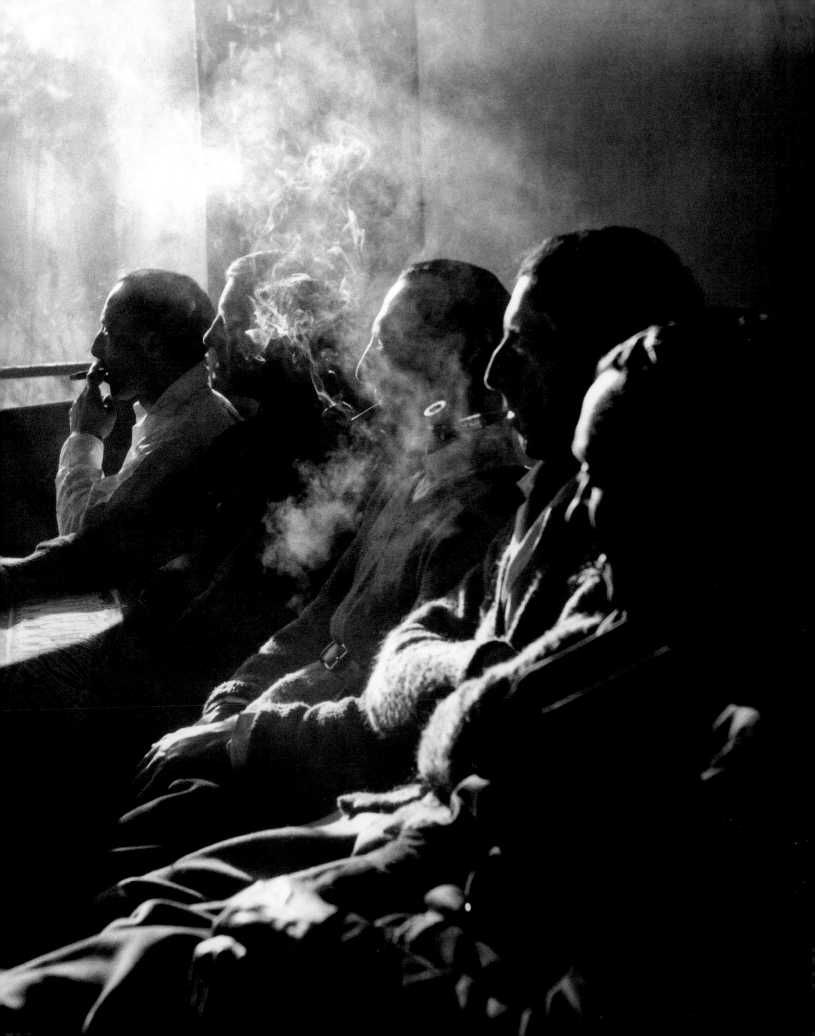

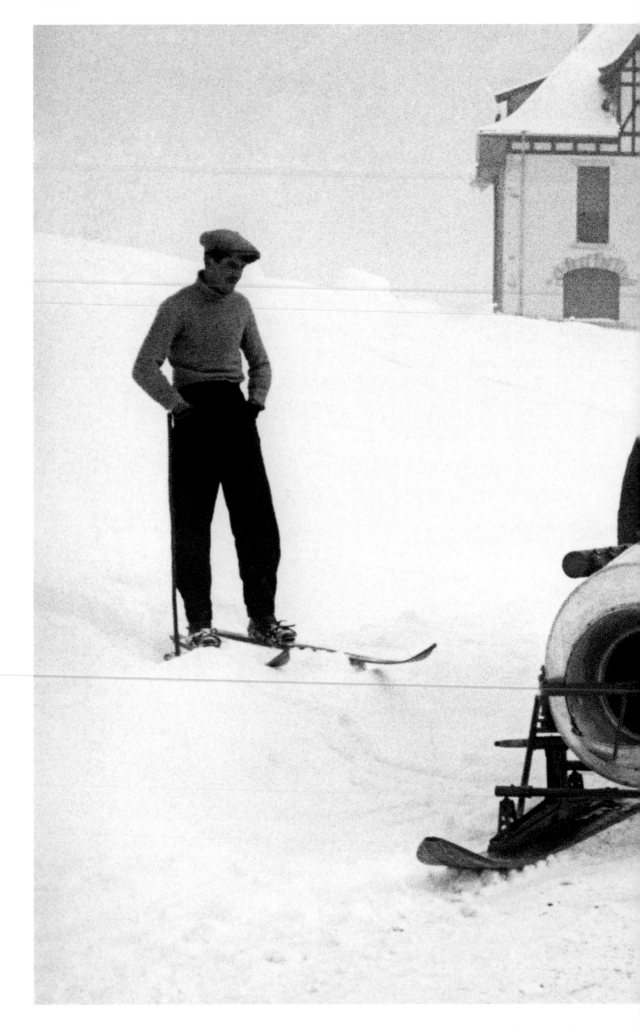

De Lesseps's sledge;
still from *Mon cinéma*,
Chamonix, France,
46 January 1914.

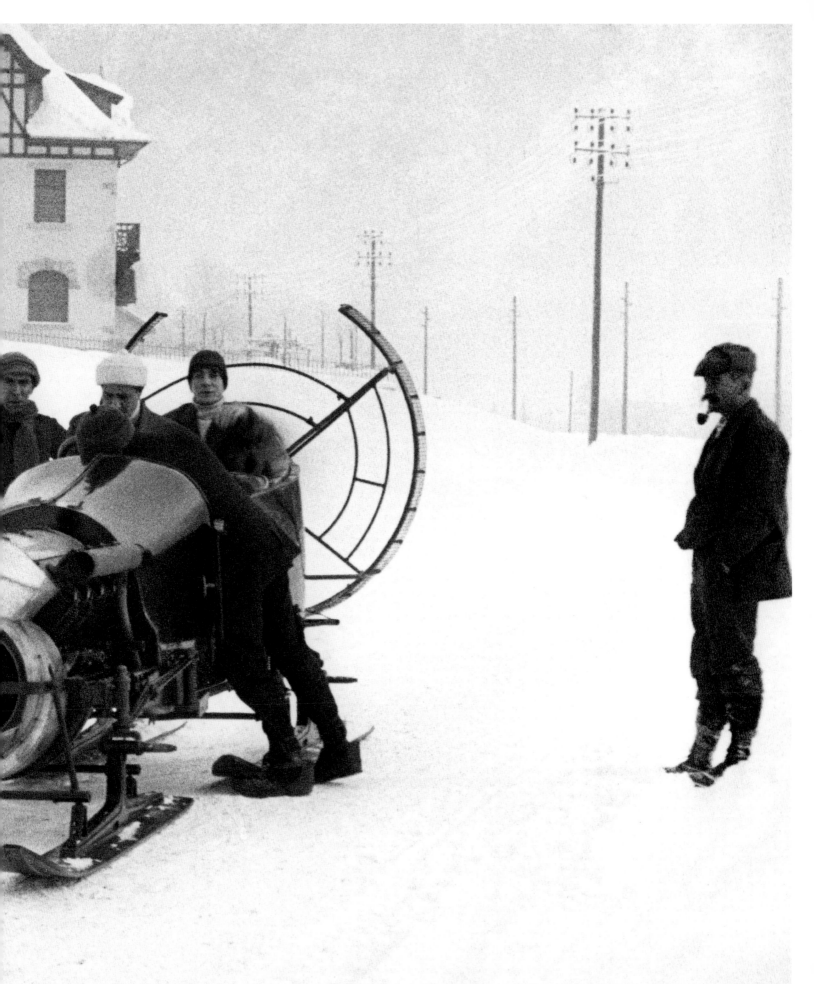

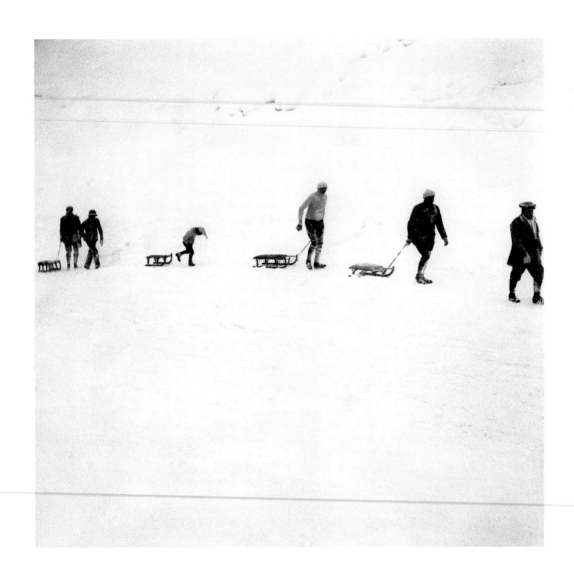

ABOVE Plitt and Zissou, Saint Moritz, Switzerland, January 1913.

FACING PAGE Chamonix, France, January 1914.

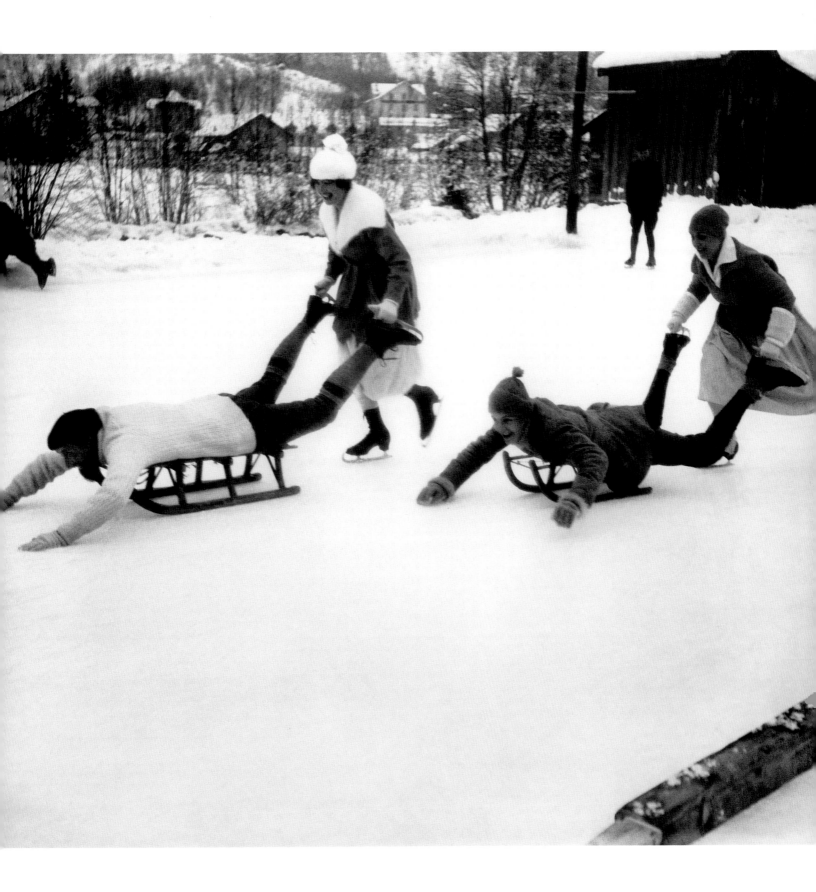

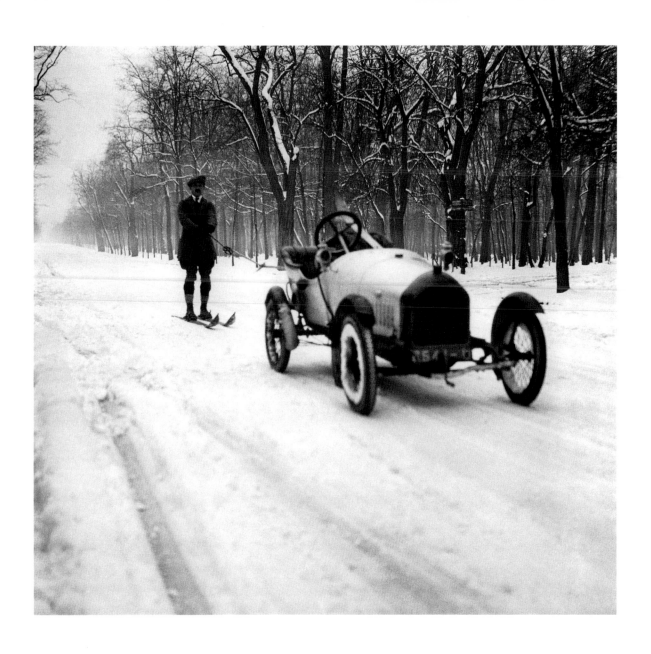

ABOVE Pigueron, Paris, February 1916.

FACING PAGE Berg, Yvonne, Mme. Chavarel, Les Bossons, Chamonix, France, January 1920.

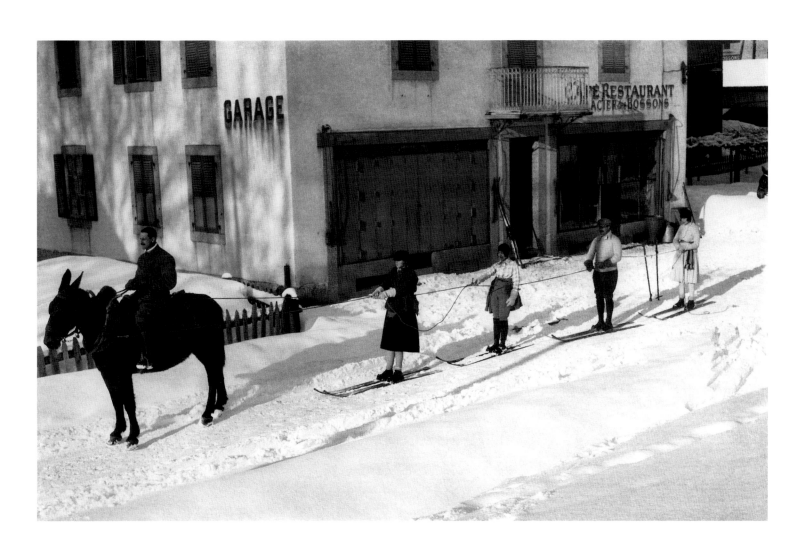

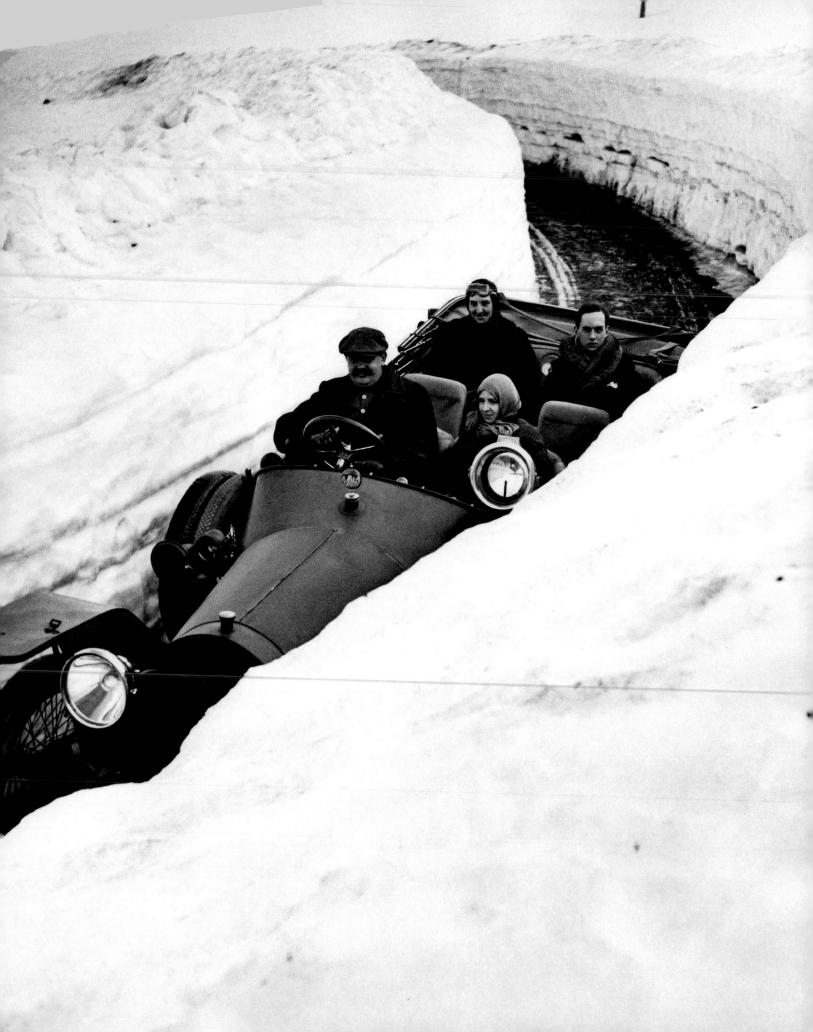

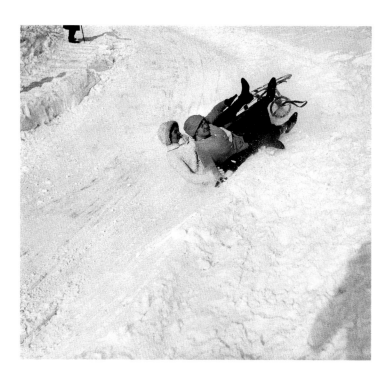

ABOVE Mlle. Estèbe and Mme. Folletête, Saint Moritz, Switzerland, January 27, 1913.

LEFT Snow walls on the Rouzat road in the Peugeot 35 HP.
Yves (driving), Bichonnade, Bouboutte, and Zissou, Col de Diane, France, April 17, 1914. **53**

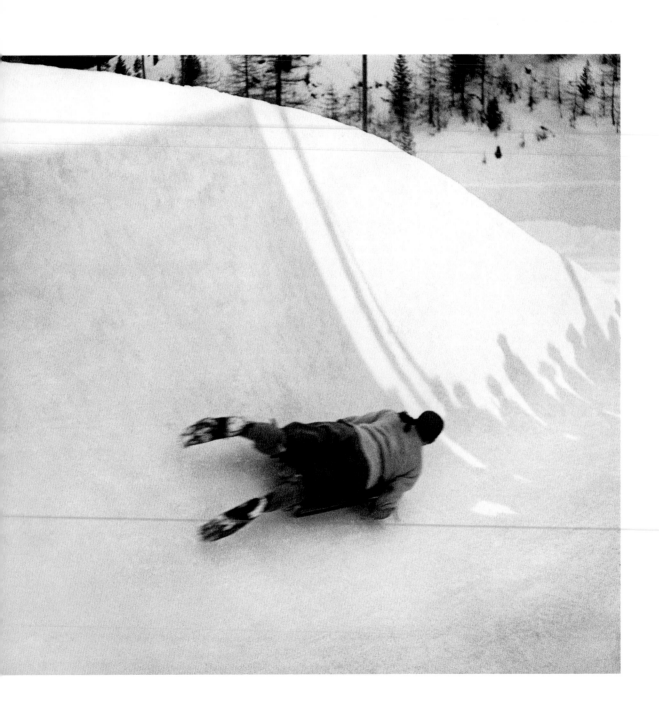

Cresta Run on a skeleton (an old-fashioned bobsleigh), Saint Moritz, Switzerland, February 1913.

FACING PAGE Plitt, Saint Moritz, Switzerland, January 24, 1913.

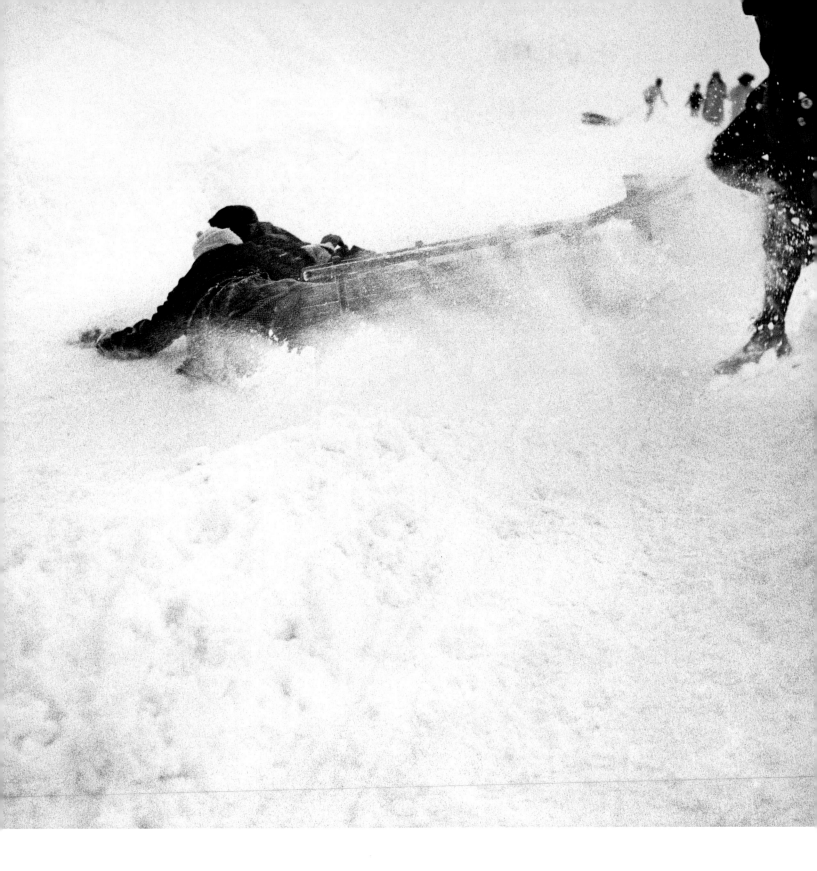

"In order to ski, one places two long, very narrow planks with turned up ends under one's feet, which one attaches to one's boots with leather straps. I've just tried it! And my fingers went numb with cold, threading and tying up the straps. As soon as one's skis are on, one starts sliding…and one's two feet are rarely in agreement and one falls on one's backside in the soft snow. But sometimes, without warning, one's feet suddenly act in unison and all of a sudden one slips over, either forward or backward depending on the kind of trick they've decided to play on you. But what does it matter, since sooner or later one inevitably falls anyway! What one is supposed to do is to go forward whilst trying to oblige the two long skis to remain parallel, at the same time as keeping one's balance…. What one has to do above all is to oblige the inside of one's head to become daring, to forget the idea that one is going to fall over. Ah, how much easier things would be if one didn't keeping getting 'ideas' all the time!"

Saint Moritz, Switzerland, January 21, 1913

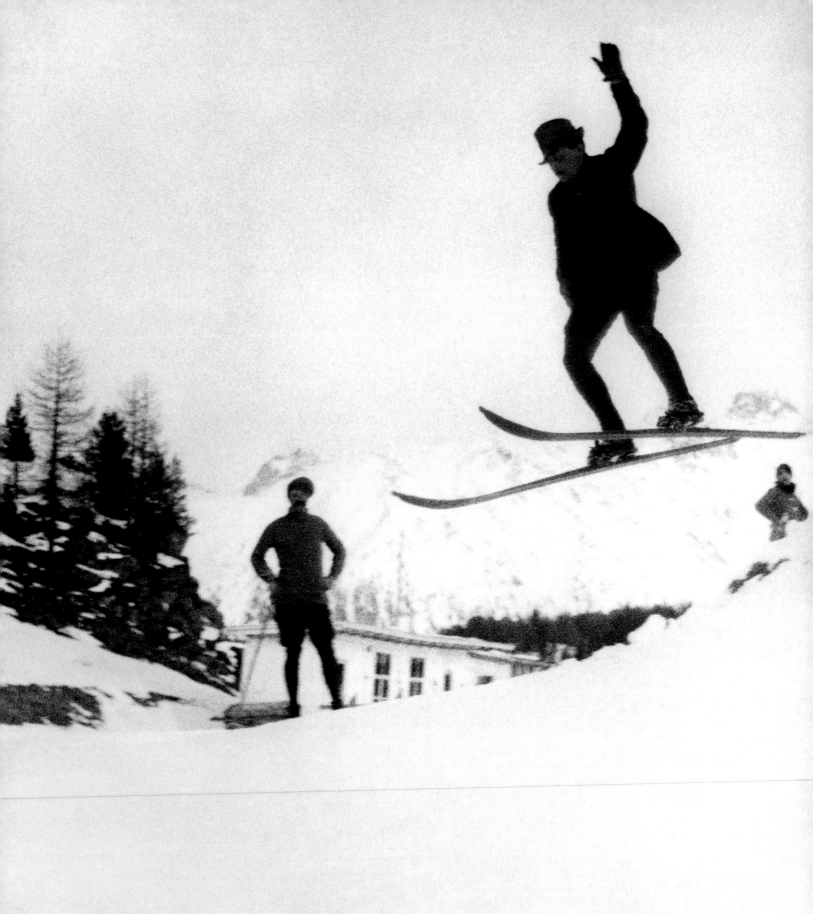

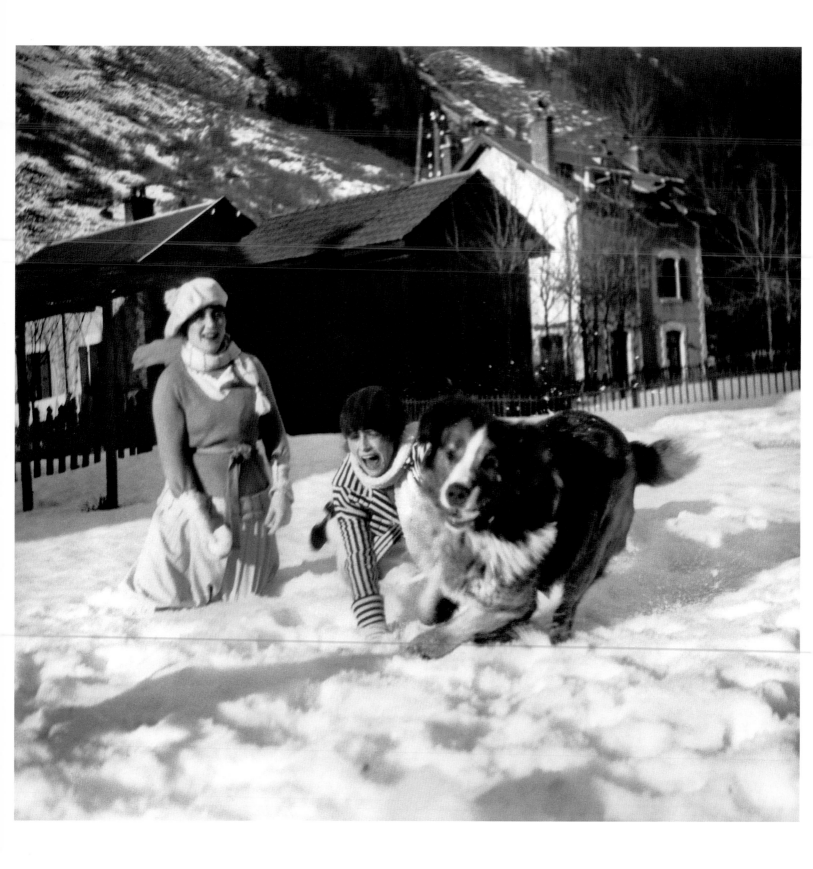

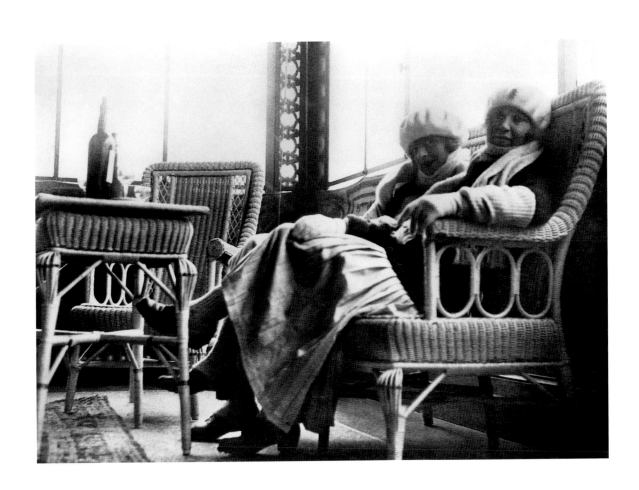

ABOVE Annette and Poussy (Baroness de Ruffe), Chamonix, France, January 10, 1918.

FACING PAGE Malvina and Annette Granger, Chamonix, France, 1918. | **59**

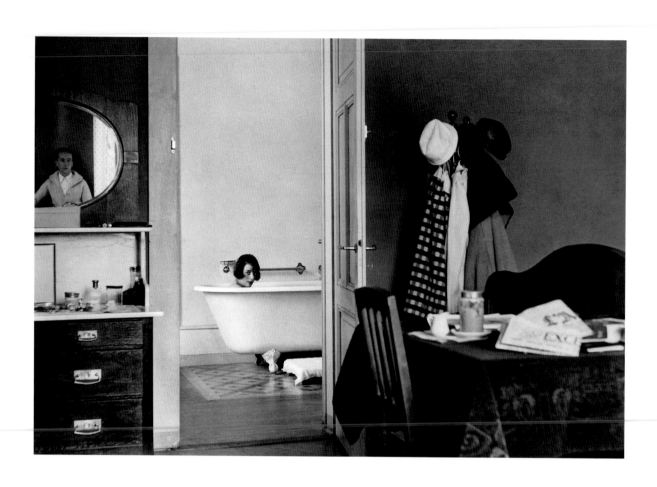

ABOVE Bibi and me in the mirror on honeymoon, Hôtel des Alpes, Chamonix, France, January 1920.

FACING PAGE Our house, Piscop, France, December 1946.

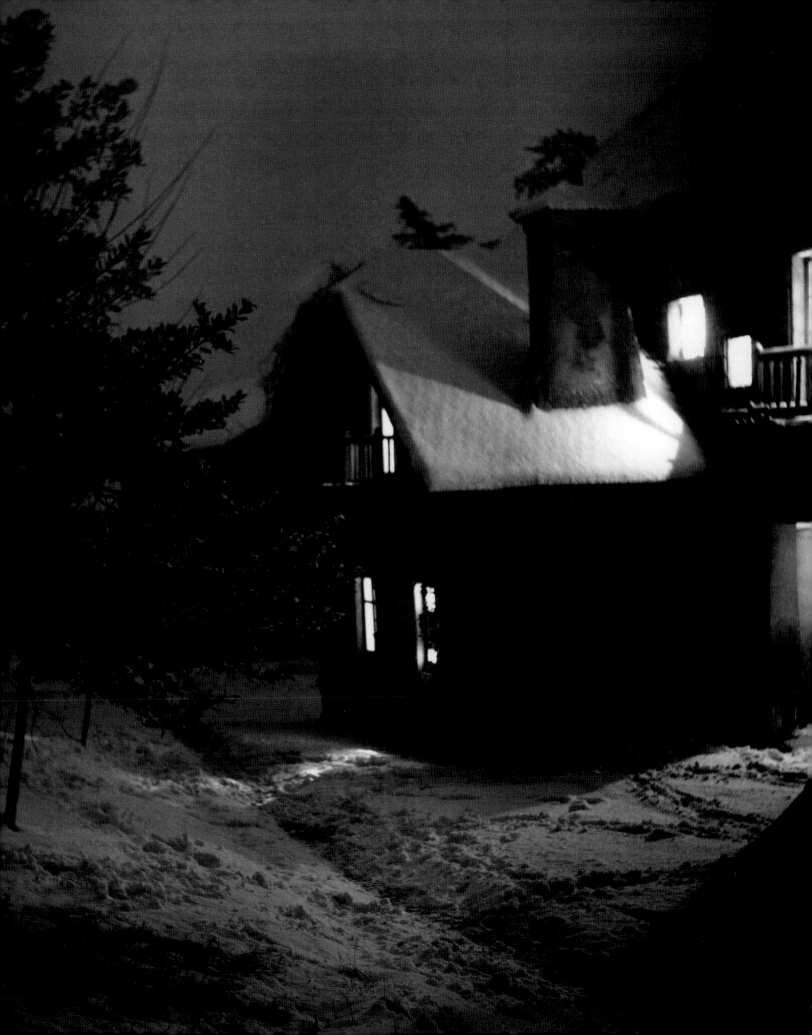

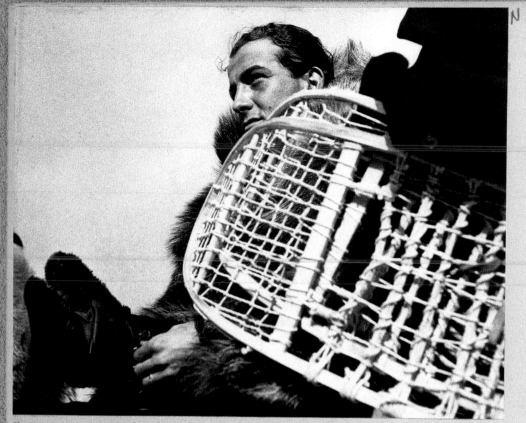

* JACQUES TERRANE

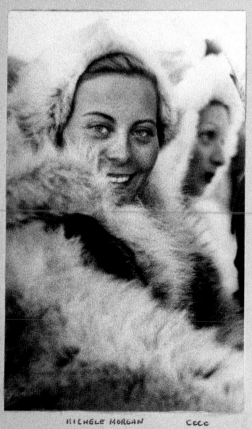

P.R. WILLM

H. MORGAN

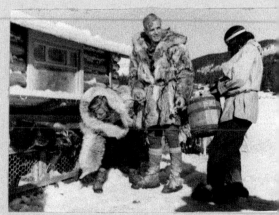

MICHELE MORGAN CECE

H. MORGAN P.R. WILLM

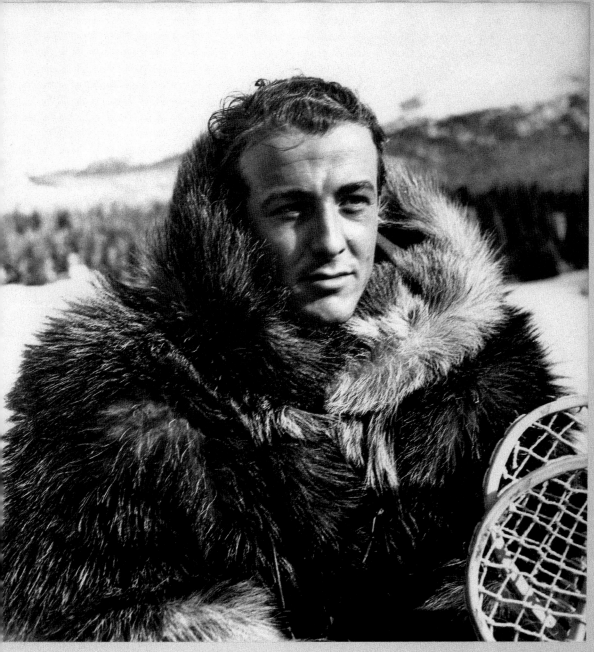

JACQUES TERRANE - JEUNE PREMIER DU FILM - FILS DE GEORGES FEYDAU

FEVRIER - VILLARS DE LANS

"Dressed up for winter sports..."

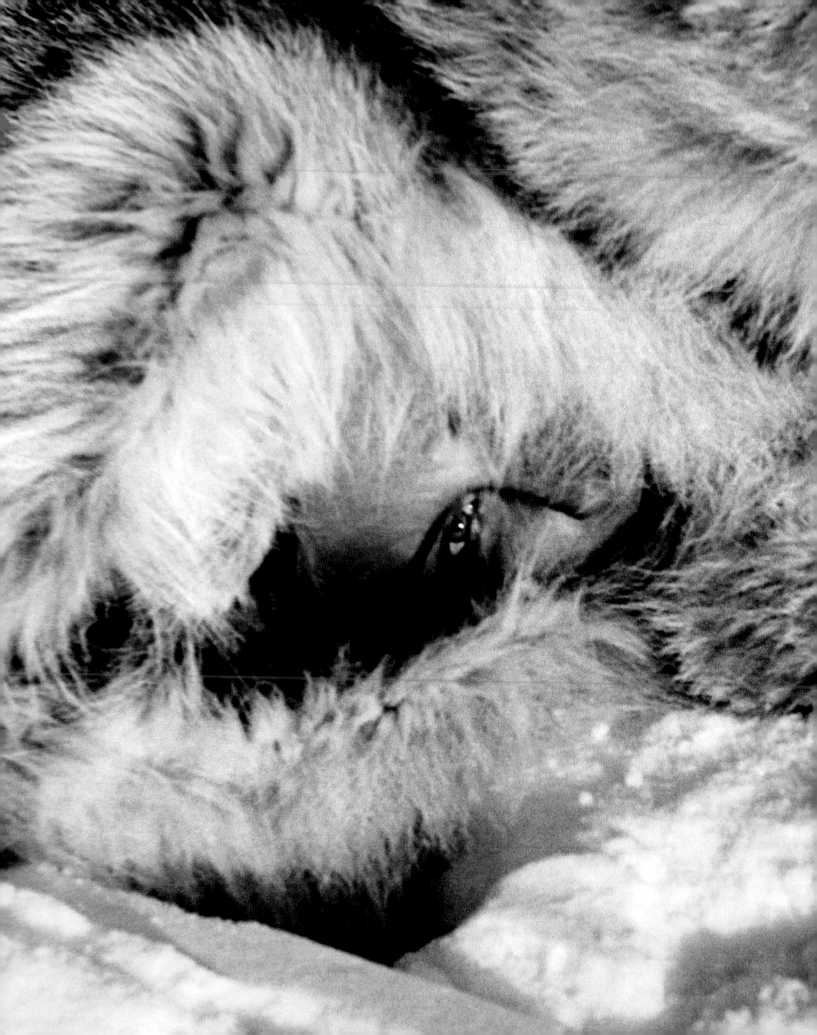

Michèle Morgan during the shooting
of the movie *La Loi du Nord*,
Villard-de-Lans, France, February 1939. **65**

"Around me people come and go, talking,
smiling as though they were on a summer beach,
seemingly content to be here enjoying themselves.
They're dressed in sweaters of every color,
with woolen balaclavas or silk caps on their heads
and things so multicolored that one wonders
how one will reaccustom oneself to the sad,
black crowds of Paris again."

Saint Moritz, Switzerland, January 21, 1913

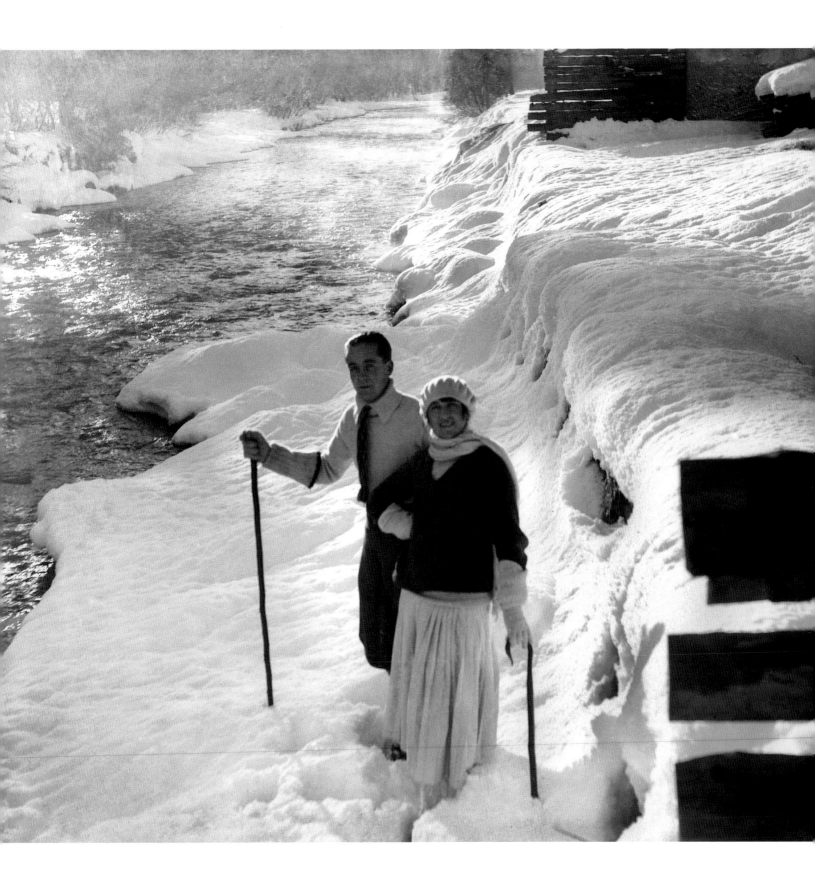

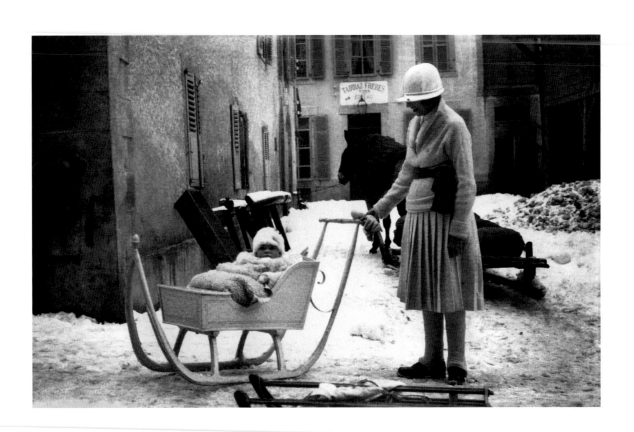

ABOVE Chamonix, France, January 1920.

68 FACING PAGE Me with Germaine, Chamonix, France, January 1914.

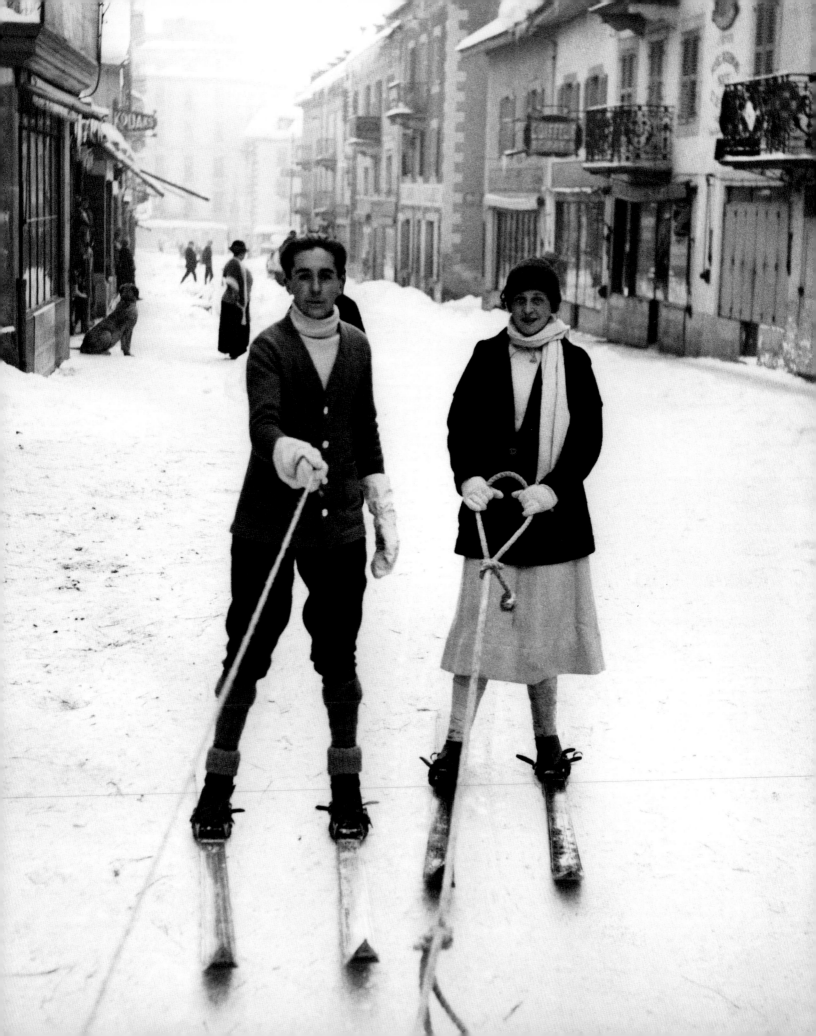

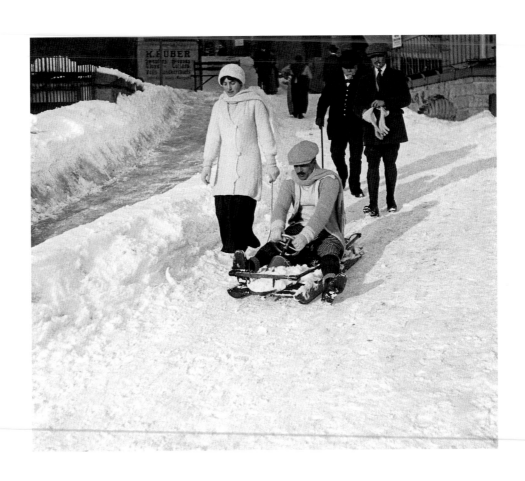

ABOVE Max Linder, Saint Moritz, Switzerland, January 24, 1913.

FACING PAGE Ostertag, me, Annette, and ZYX (Zissou), Chamonix, France, 1918.

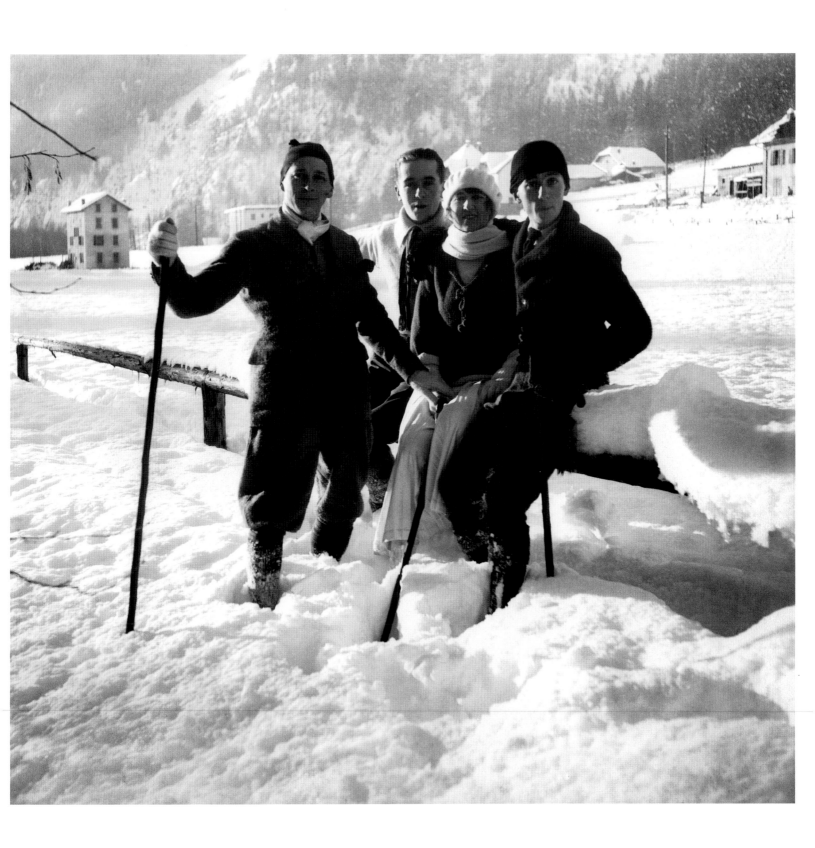

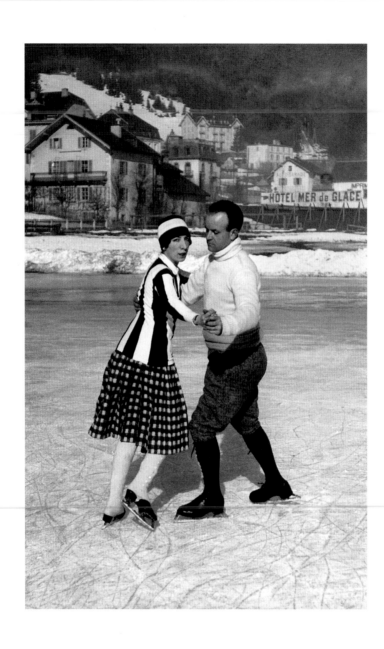

ABOVE Nicole and André Groult, Chamonix, France, January 1918.

FACING PAGE Bibi, on honeymoon, Chamonix, France, January 1920.

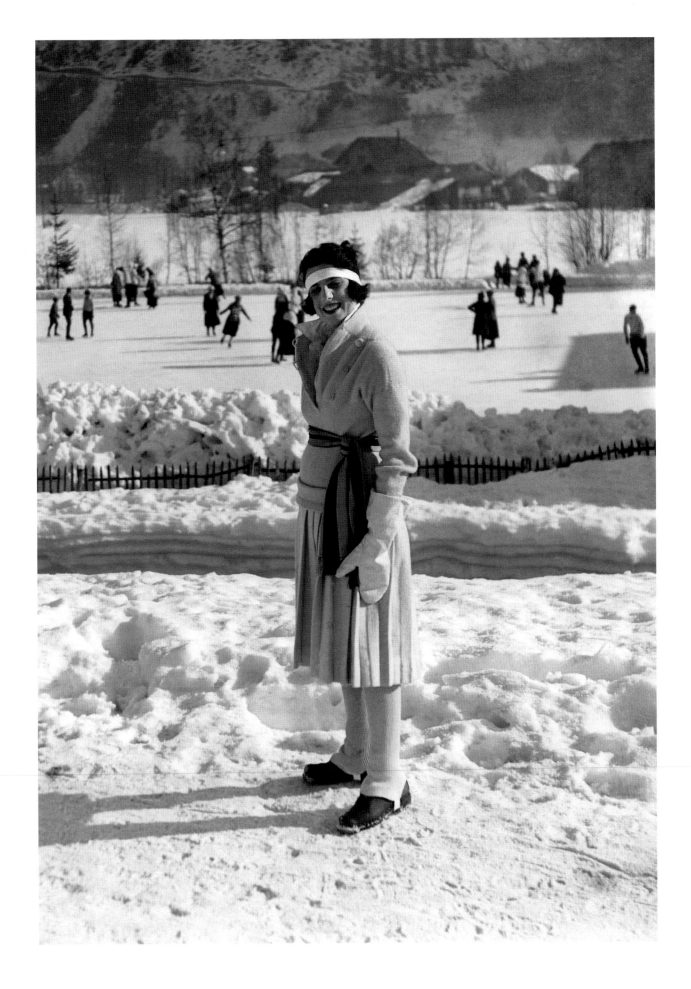

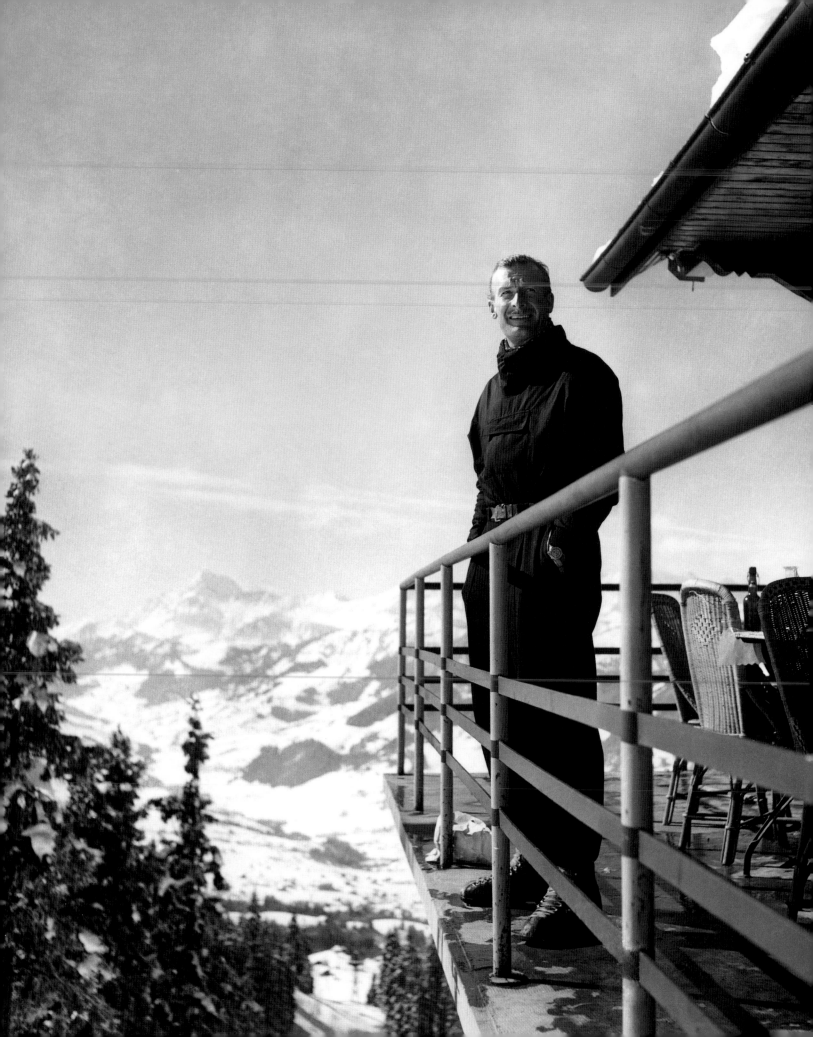

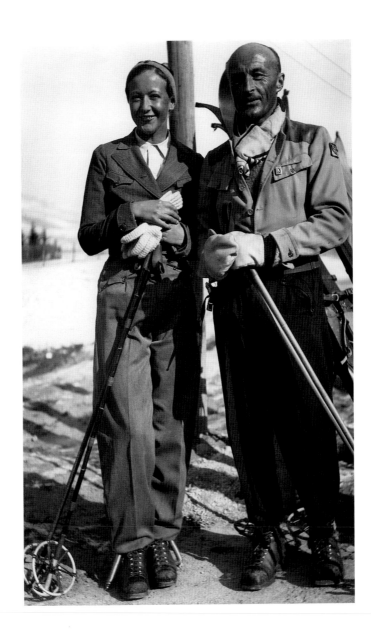

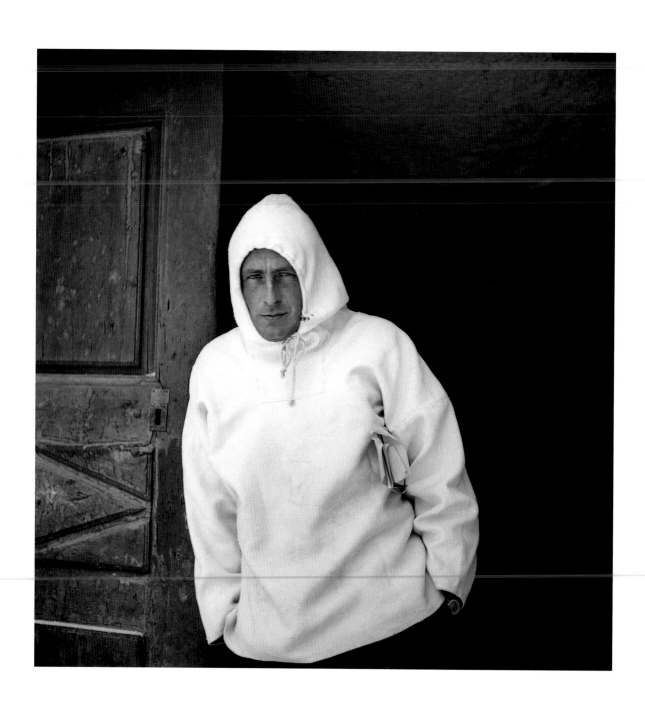

ABOVE Paul-Émile Victor, Mont Genèvre, France, February 1939.
FACING PAGE Doriane on Mont d'Arbois, Megève, France, January 1930.

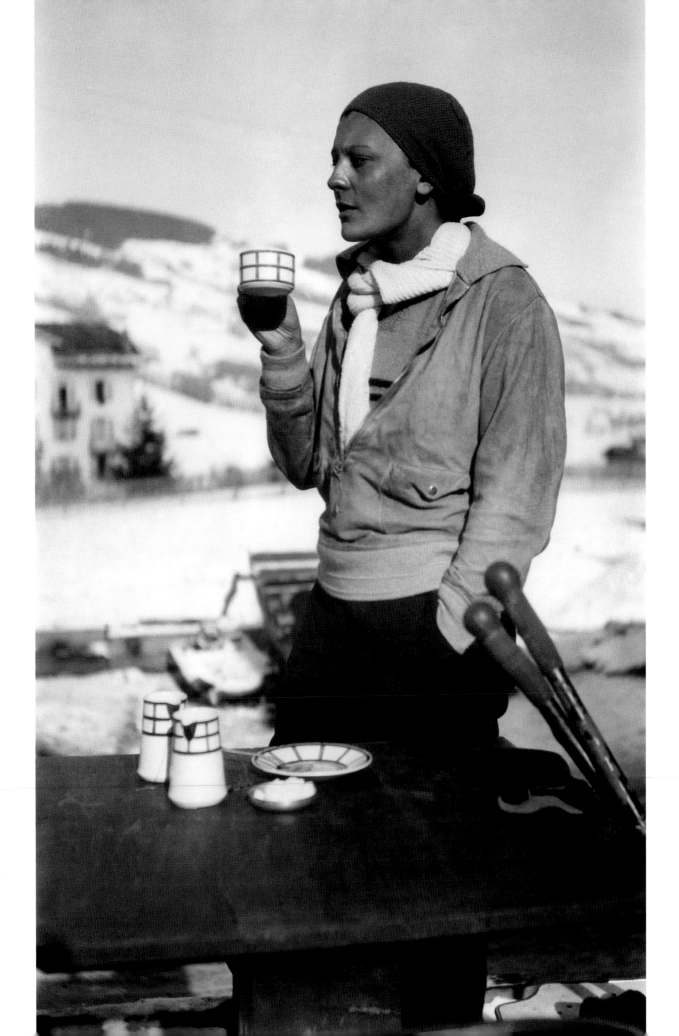

RIGHT Zissou and Sim, Saint Moritz, Switzerland, January 1913.

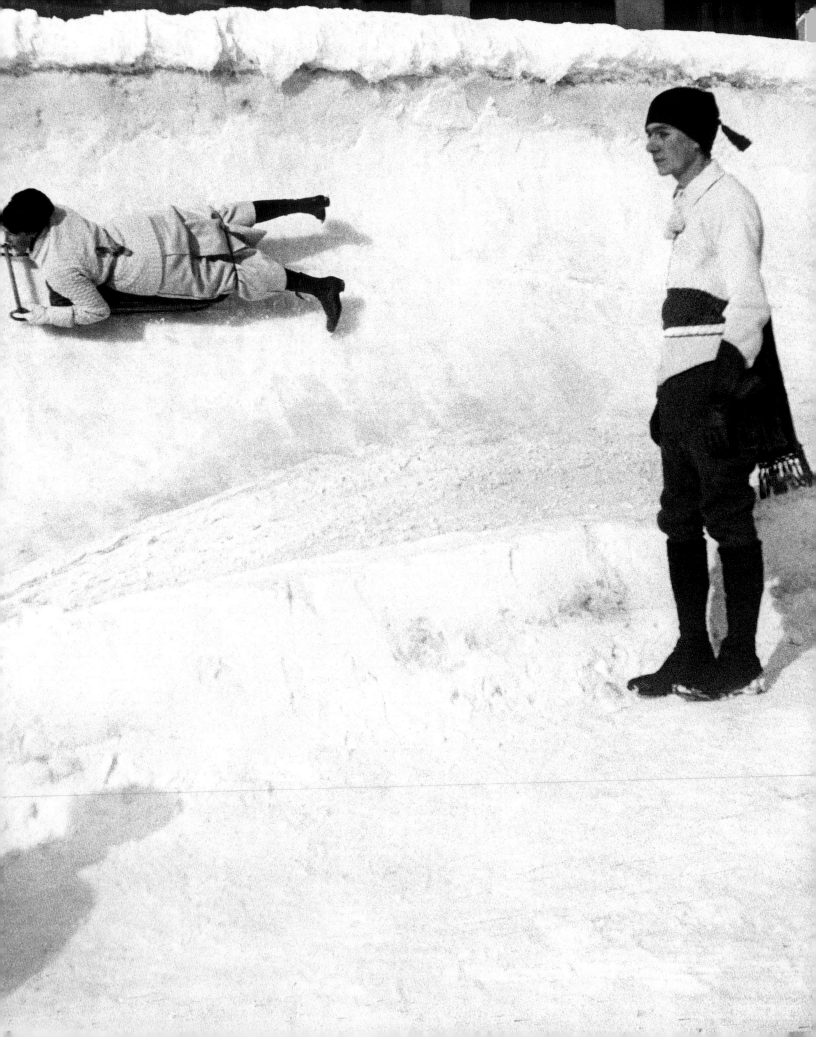

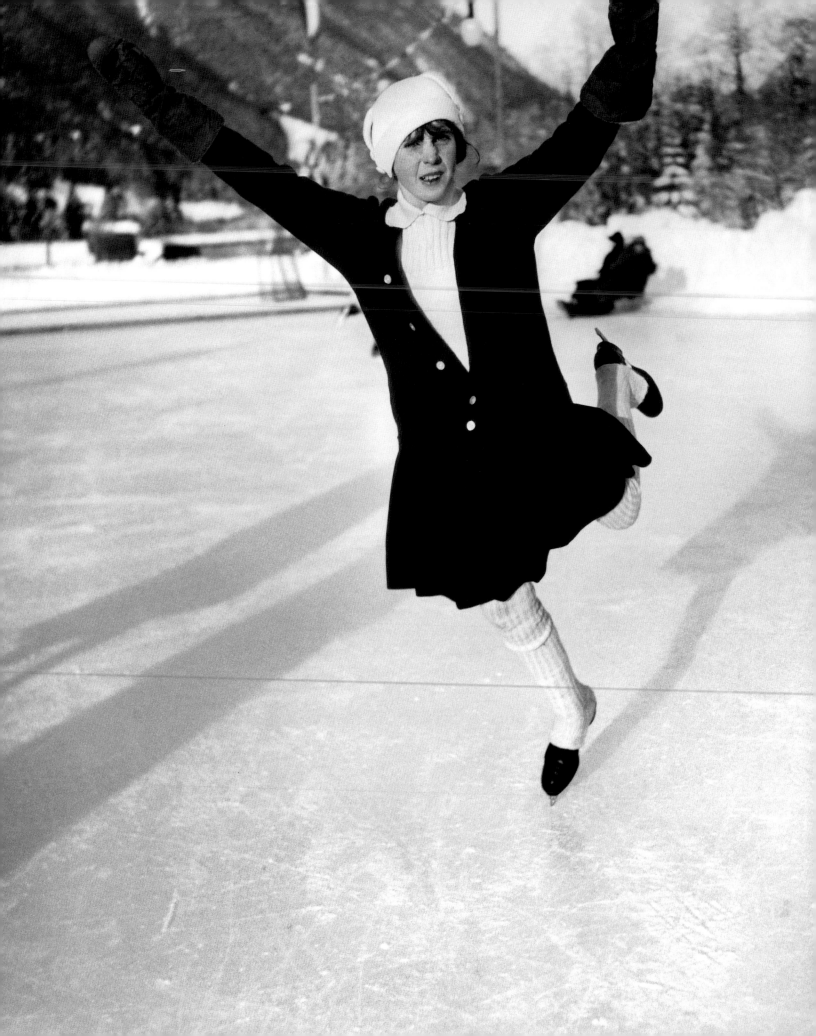

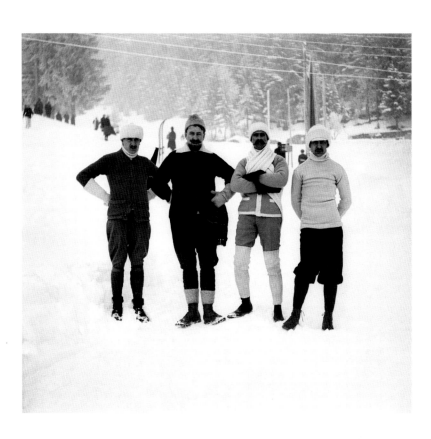

ABOVE Maréchal, Doctor André, Berg, and Zanfiresco, Chamonix, France, January 18, 1914.

LEFT Yvonne Bourgeois, Chamonix, France, January 1914. **81**

"Paris isn't wonderland like Saint Moritz. In the snow we were
as free as a bird, it was dazzling, perfumed with the smell of sky
and sun. But here, the smell of the Palais de Glace is perhaps
the smell of the thick carpet along the promenade gallery, or the ice,
or a perfumed girl, or my skating shoes waiting for me in the locker
room…. As soon as one goes through the big door one enters
the wind-like noise of all those skates sliding over the ice at once,
mixed with the murmur of people talking as they go around the rink,
and strains of pleasant, languorous, waltzing music. Fashionable
tunes that everyone knows by heart: *Quand l'amour meurt,*
Vous êtes si jolie, Quand l'amour refleurit, Les Millions d'arlequins,
Le printemps chante, España, Le Pas des patineurs, La Petite
Tonkinoise, and all Octave Cremieux's waltzes, reverberating
and flying around the great round space of the ceiling. One ought
to be able to 'photograph' noises in order to explain them."

Paris, February 1913

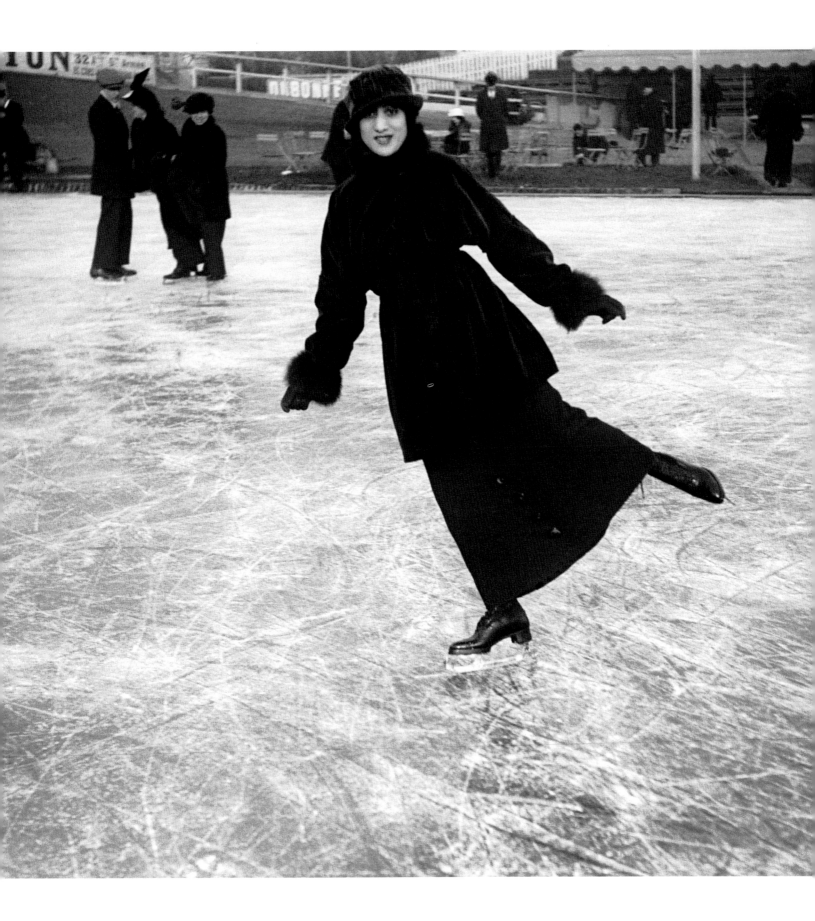

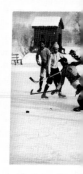

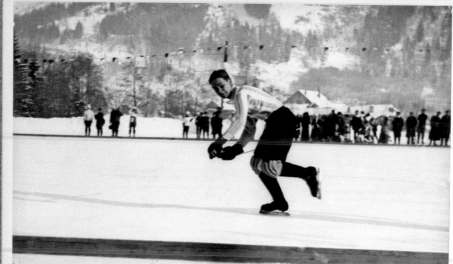

TAYLOR

EQUIPE DE FRANCE AVANT LE MATCH

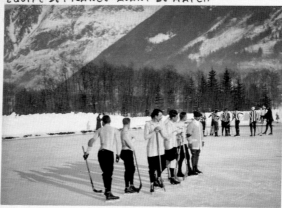

BOBY LACROIX - ZANFIRESCO - P

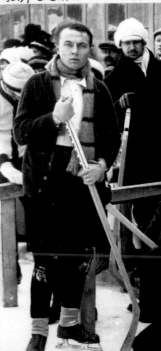

MOI - MARCELLE BOURLIER MONSIEUR BOURGEOIS
 ZANIRES CO - Mᵐᵉ BOURGEOIS - SUZ - MADELEINE

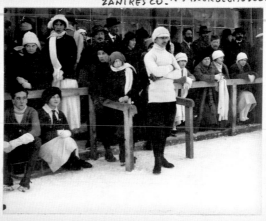

* 90.

MARCELLE

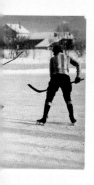

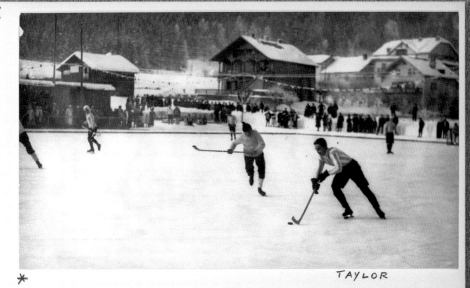

TAYLOR

*

KIKI GUIBERT

N. GERMAINE_OPHELIA _ RICHY. M⁻RICHY. MADELEINE_YVONNE BOURGEOIS

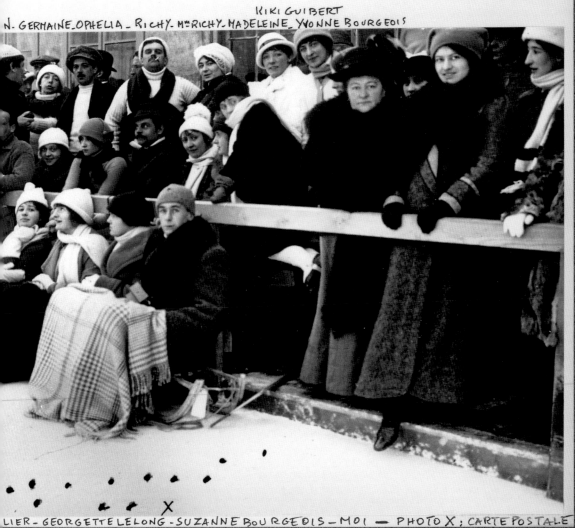

LIER - GEORGETTE LELONG - SUZANNE BOURGEOIS _ MOI — PHOTO X ; CARTE POSTALE

"What amuses me more than trying to be graceful is speed…"

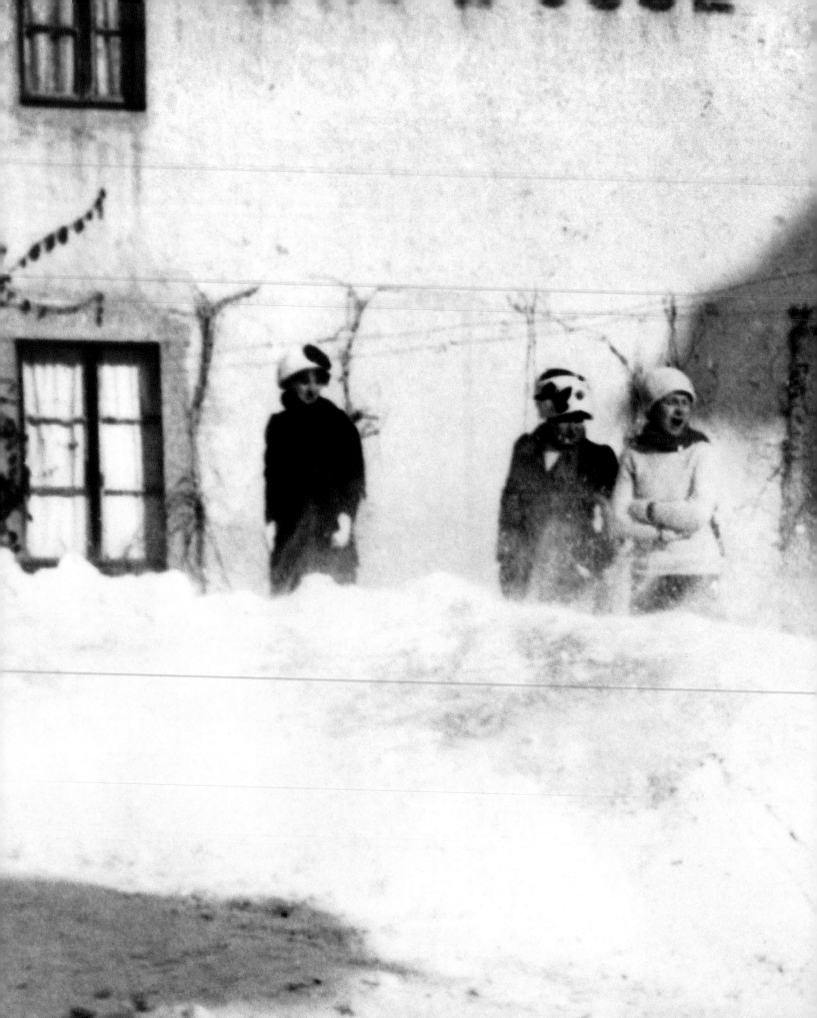

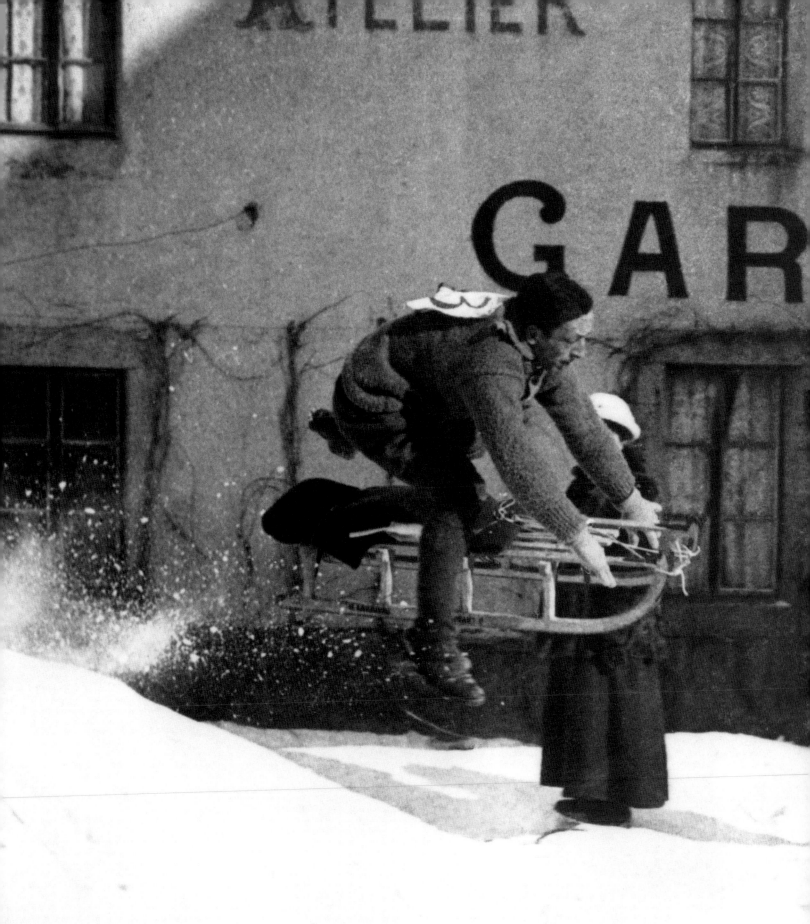

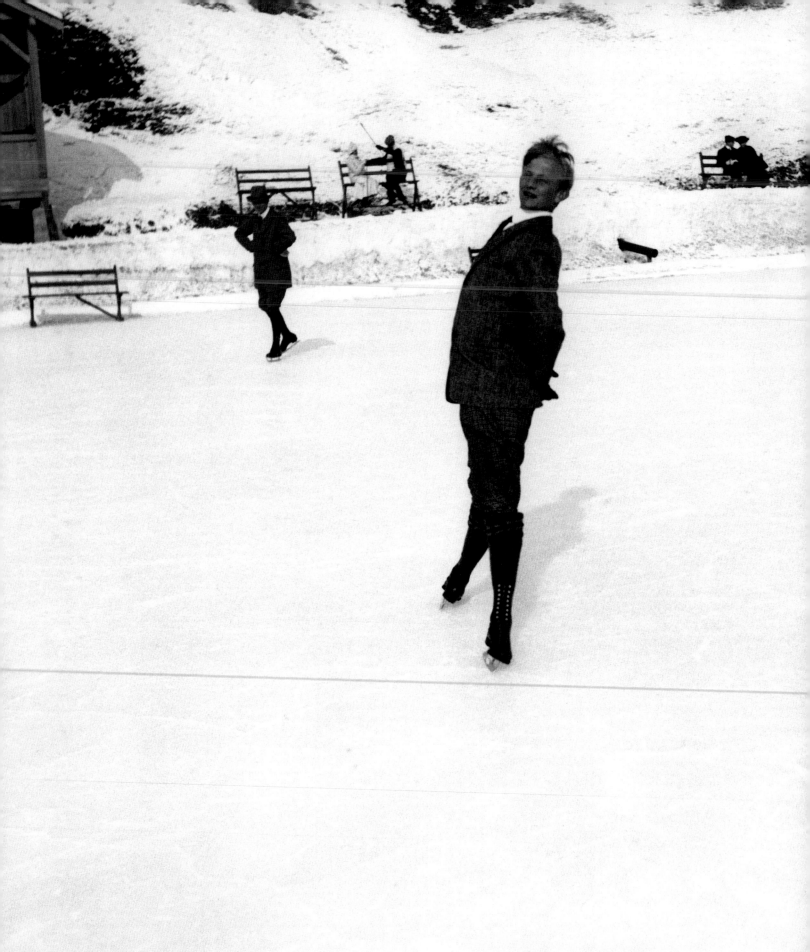

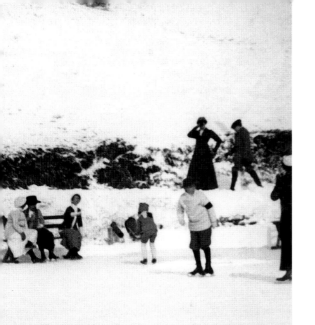

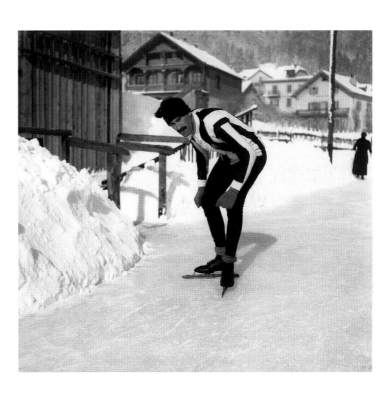

PRECEDING DOUBLE PAGE Francis Pigueron on a sled,
coming off a bend, Chamonix, France, January 1914.
ABOVE Quaglia, French speed-skating champion, Chamonix, France, January 1920.
LEFT Williams, ice-skating championship, Palace skating rink,
Saint Moritz, Switzerland, February 15, 1913. **89**

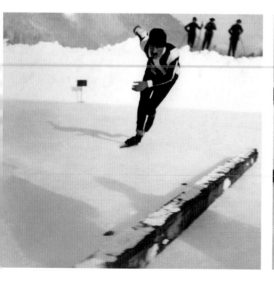 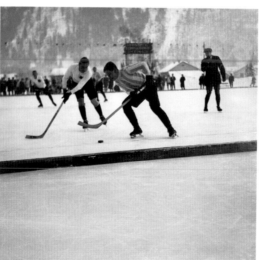 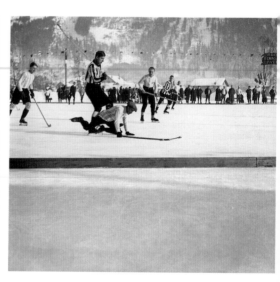

LEFT Quaglia, French speed-skating champion, Chamonix, France, January 1920.

CENTER Ice-hockey championships, Chamonix, France, January 1914.

90 RIGHT Taylor and Bobby Lacroix, ice-hockey championships, Chamonix, France, January 1914.

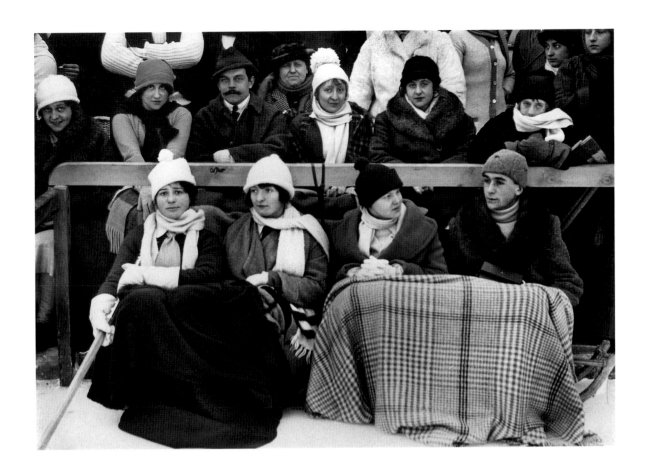

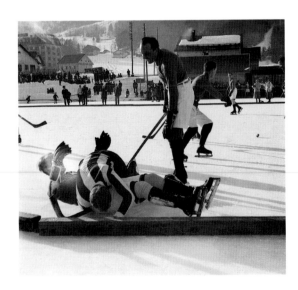

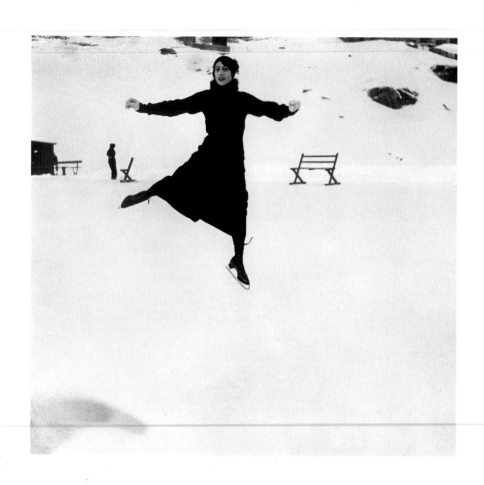

aint Moritz, Switzerland, 1913.

competition at the skiing school, Saint Moritz, Switzerland, February 1913.

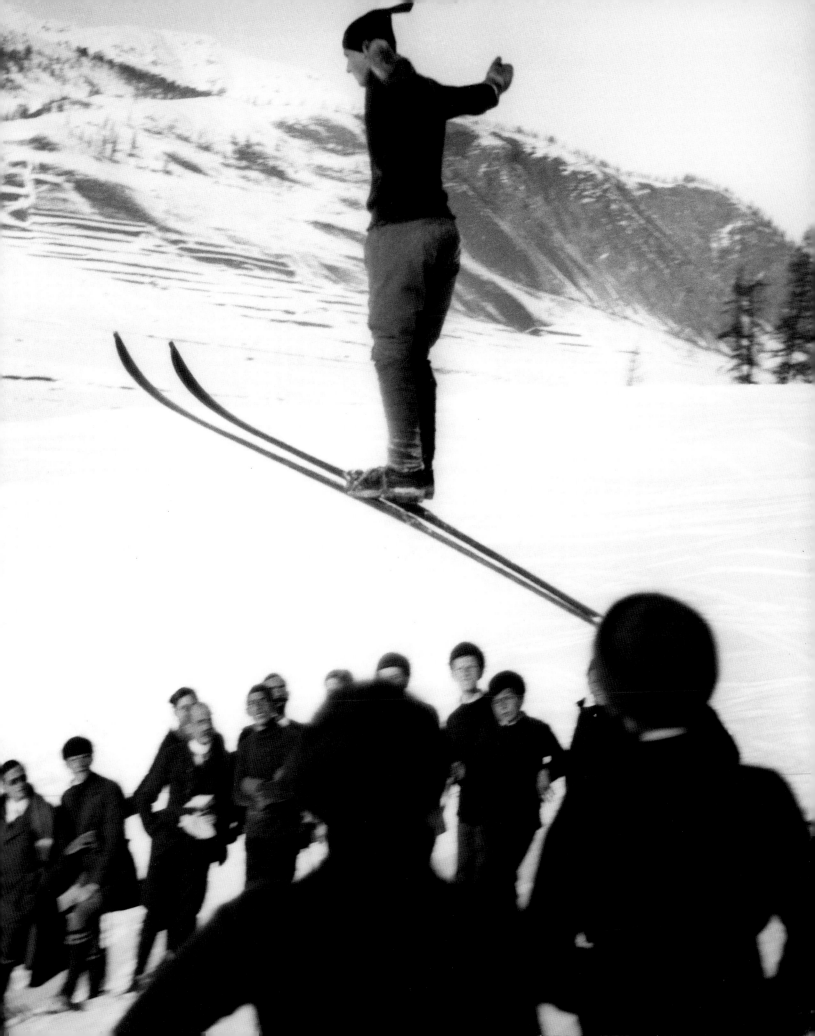

"…Something dazzling happening on ground
that is lighter than the sky, ground that crunches
underfoot, soft, silent, which erases all noise…
To go to the high mountains in midwinter!
Many people in France say one would have
to be mad. But here, for three or four years now,
I have seen all these English and American people,
as well as a few rare French who have also
come here to try what is now called 'winter sports.'"

Saint Moritz, Switzerland, January 21, 1913

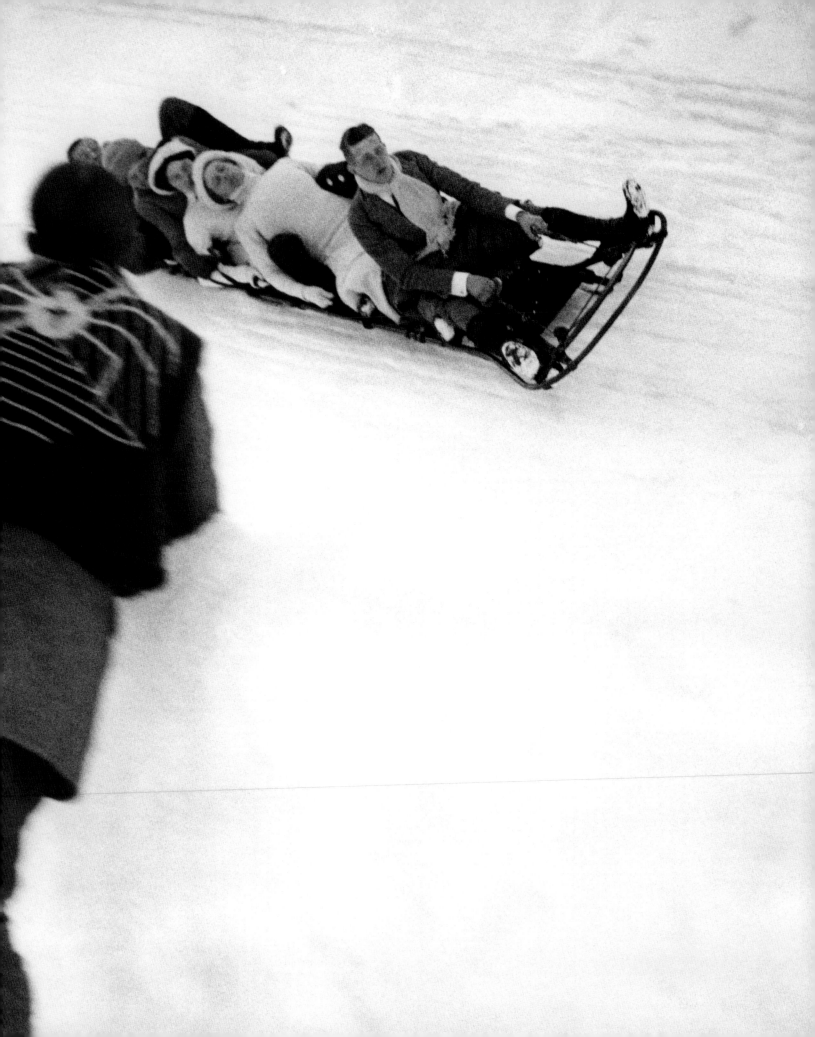

"…I also saw Graham White,
the famous English aviator, skijoring,
the horse pulling him ridden by a woman.
The only person to dress all in black,
he looks like a negative of a ghost."

Saint Moritz, Switzerland, January 21, 1913

RIGHT A new sport: skijoring, Saint Moritz, Switzerland, January 1913.

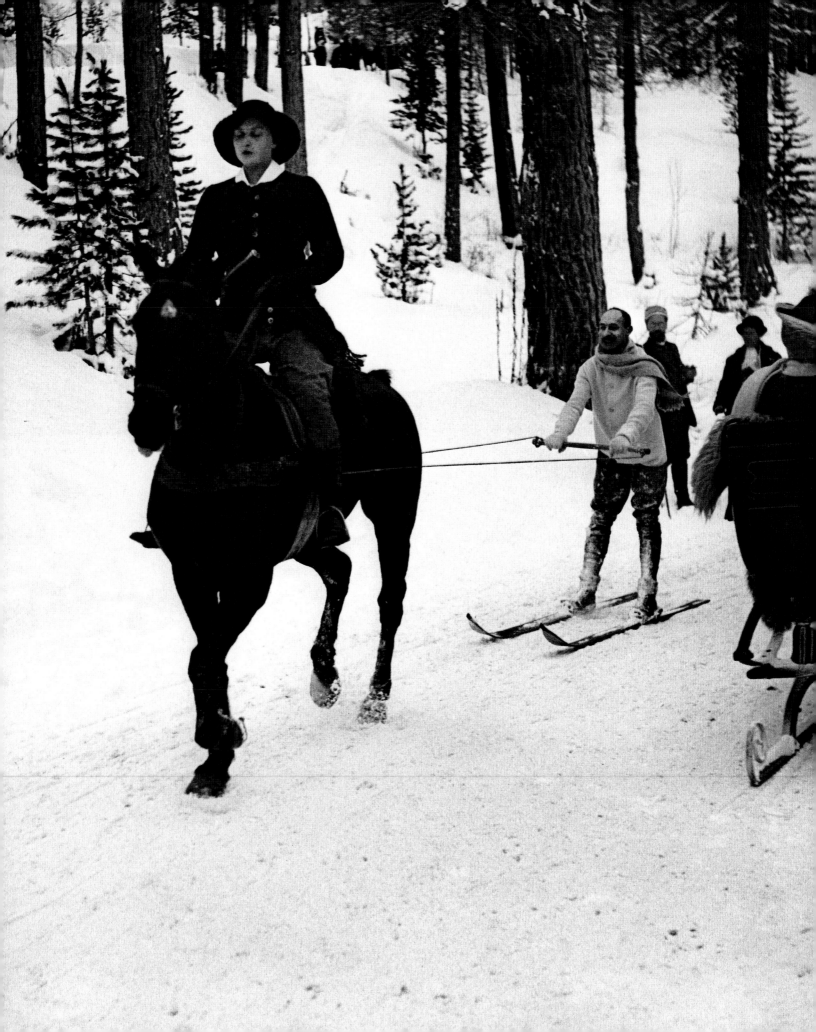

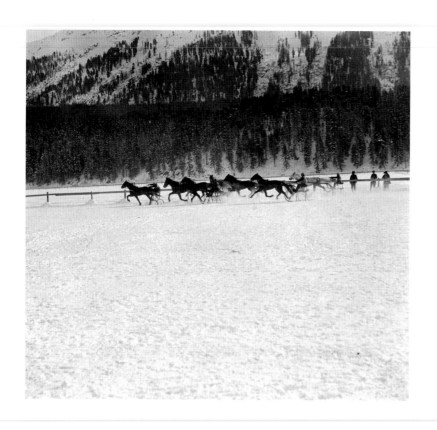

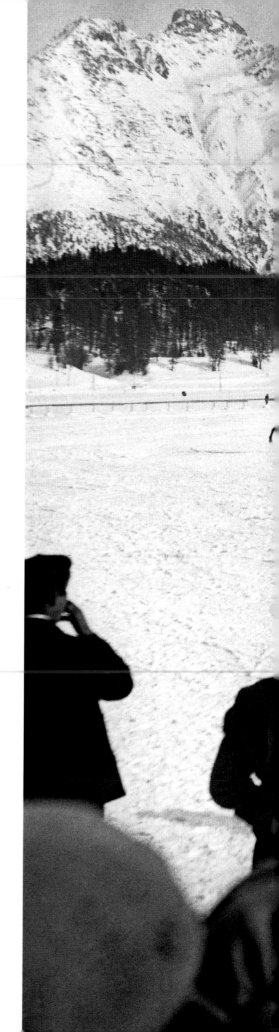

ABOVE Horse race on the lake, Saint Moritz, Switzerland, February 1913.

RIGHT Skijoring, Saint Moritz, Switzerland, February 1913.

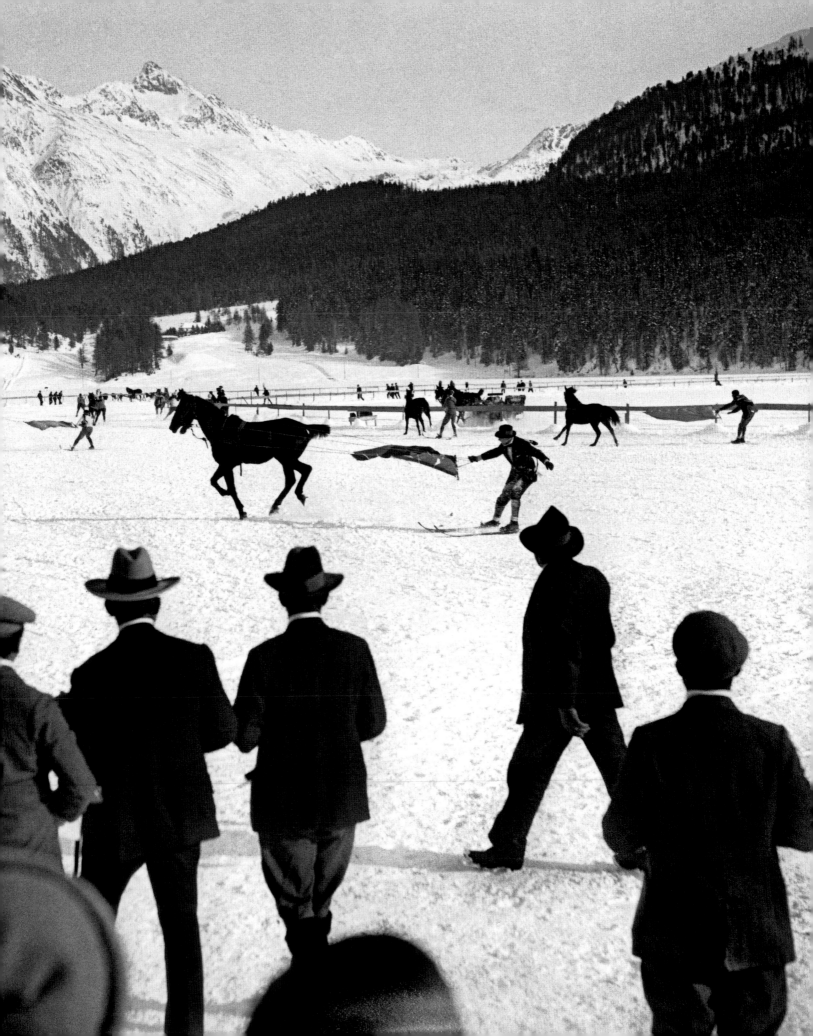

RIGHT Albert Heïdé, Francis Pigueron, and Ostertag, Chamonix, France, January 1918.

100 FOLLOWING DOUBLE PAGE Bobsleigh championship, Saint Moritz, Switzerland, January–February 1913.

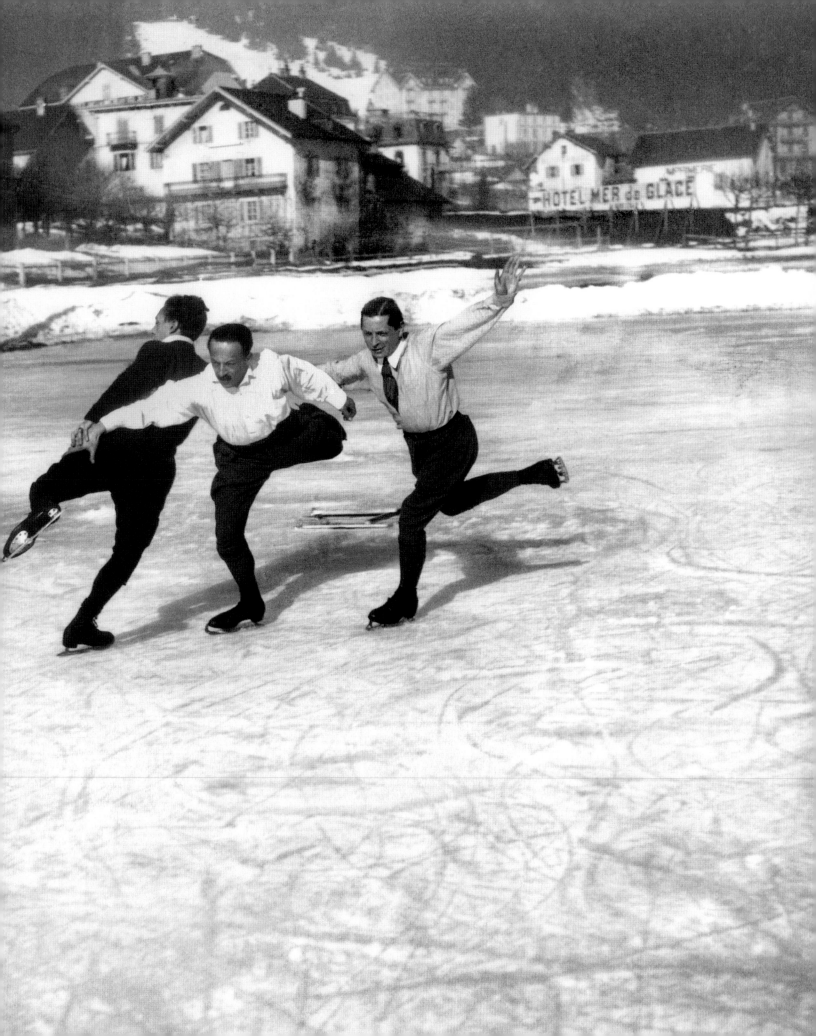

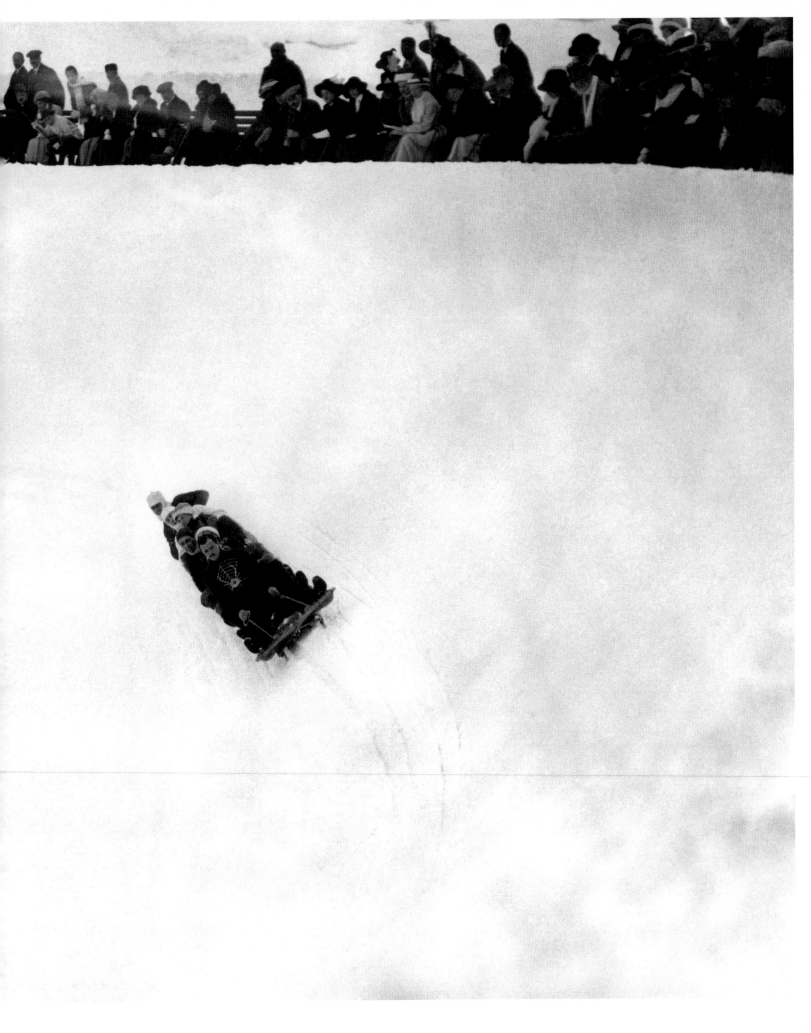

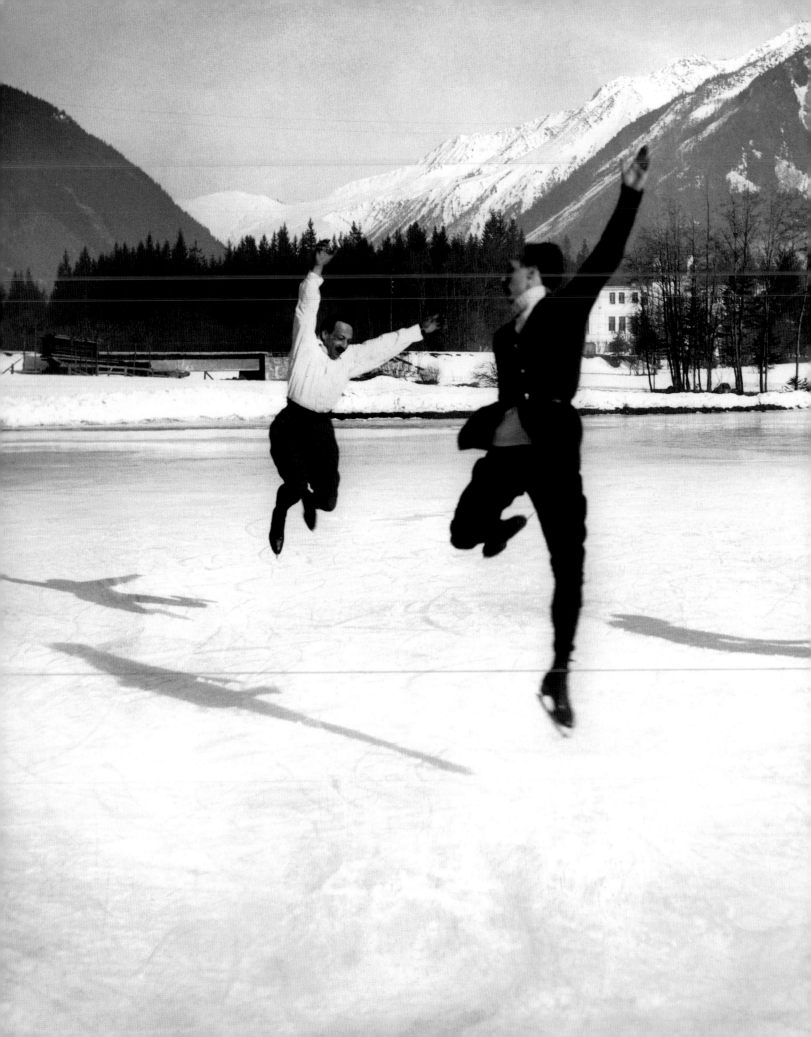

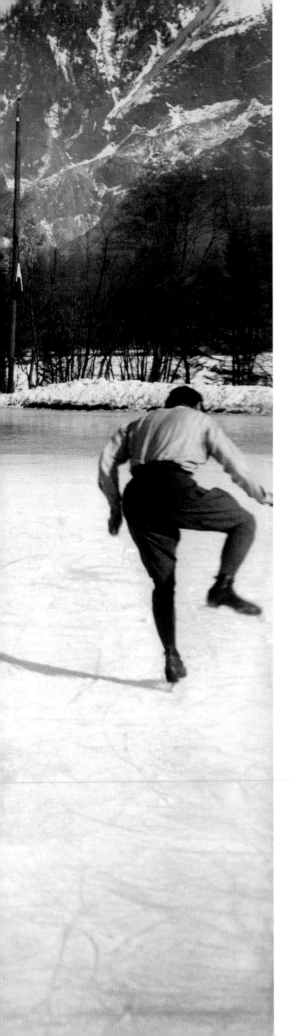

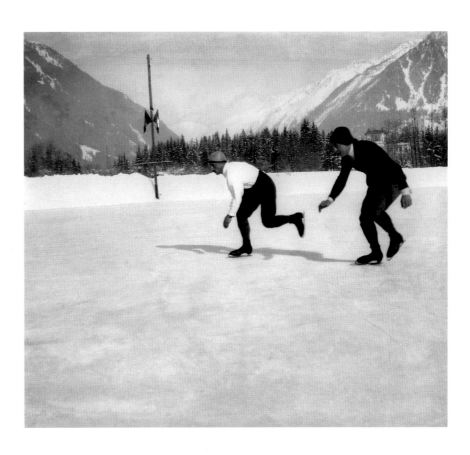

ABOVE French ice-skating championships, Chamonix, France, January 1919.

LEFT Chamonix, France, January 1918. | **105**

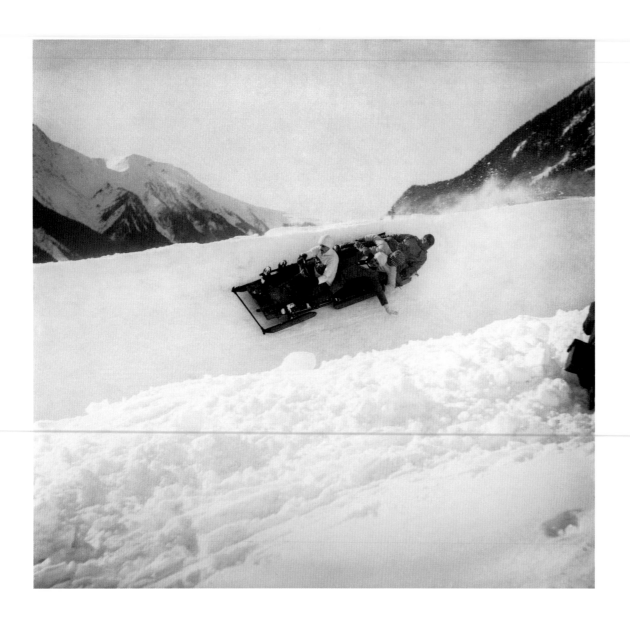

ABOVE Berg's bobsleigh, Chamonix, France, January 1920.

FACING PAGE Chamonix, France, January 1919.

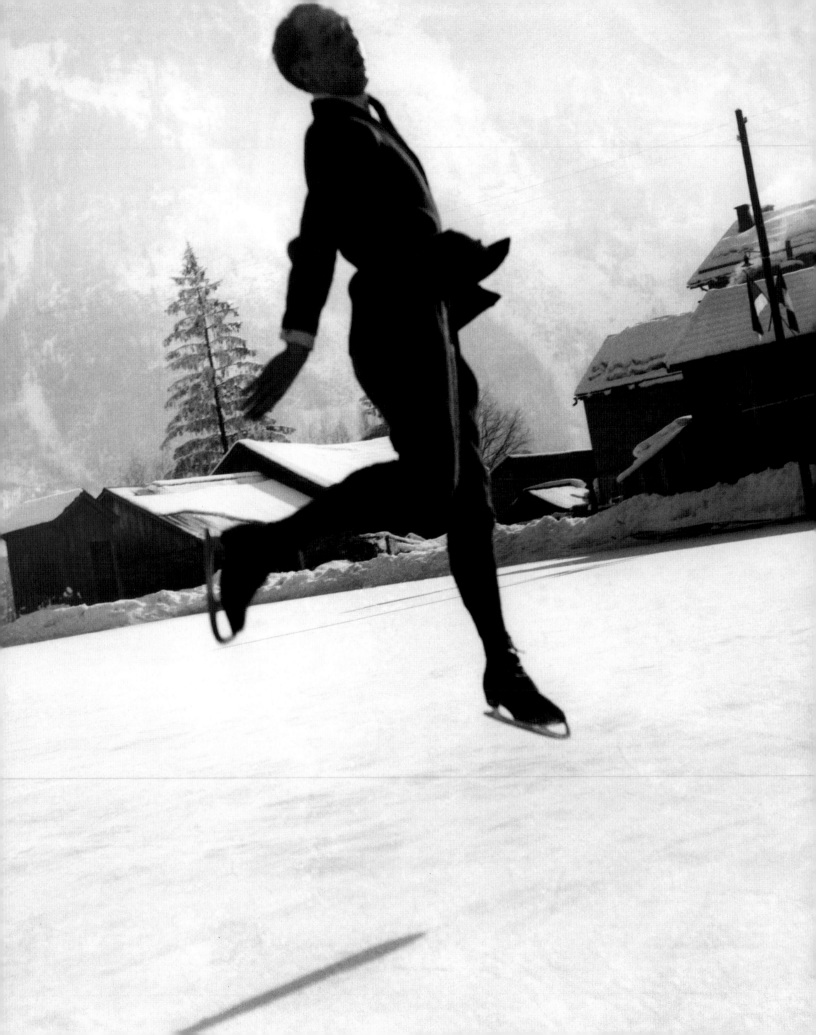

A. HEIDE

MOI

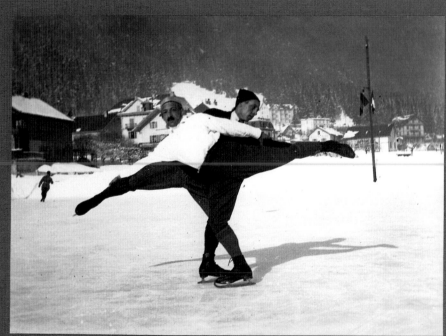

PIGUERON - HEIDE

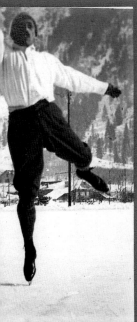

PIGUERON x

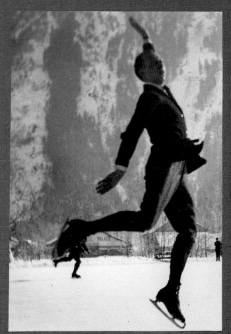

HELDE x

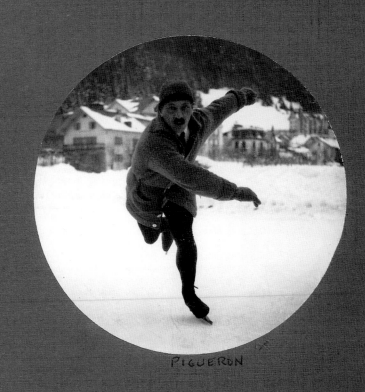

PIGUERON

"Deadly boring people who pigeonhole everything call me a 'visual' person."

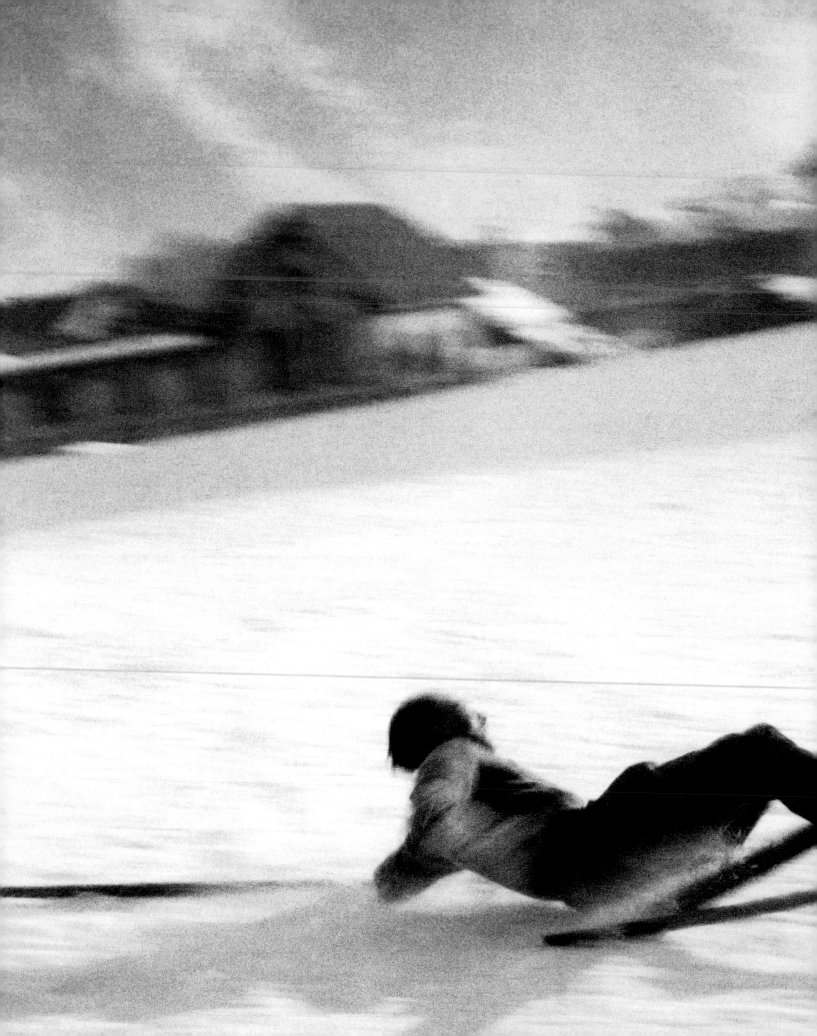

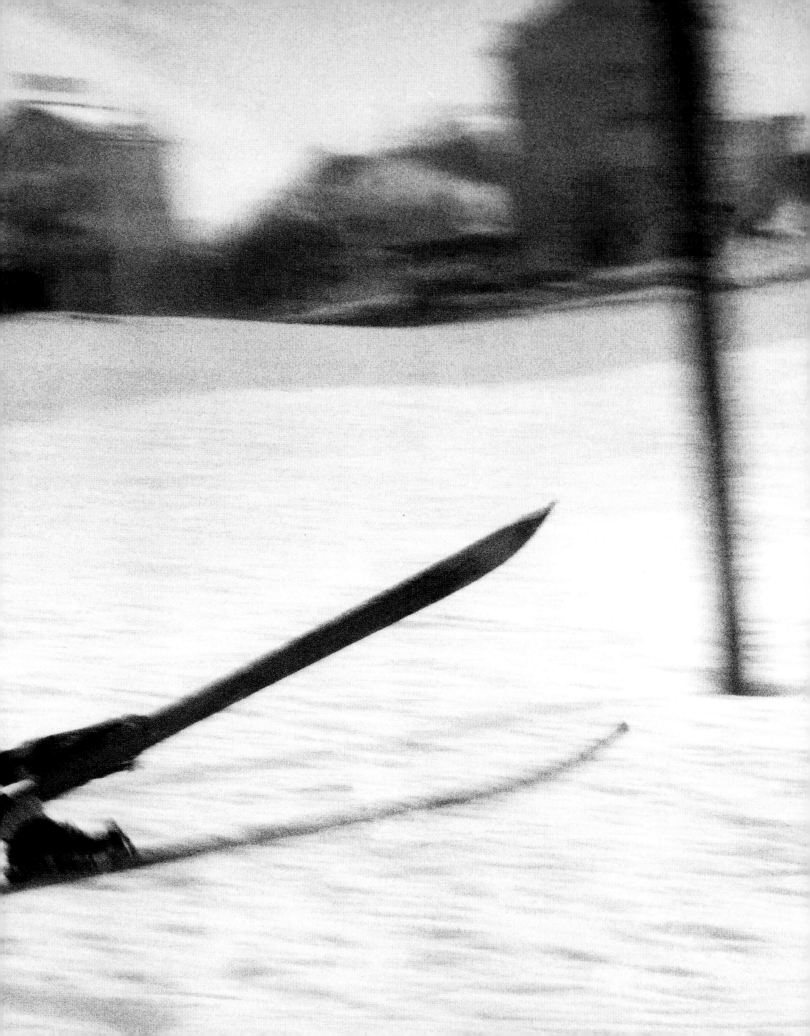

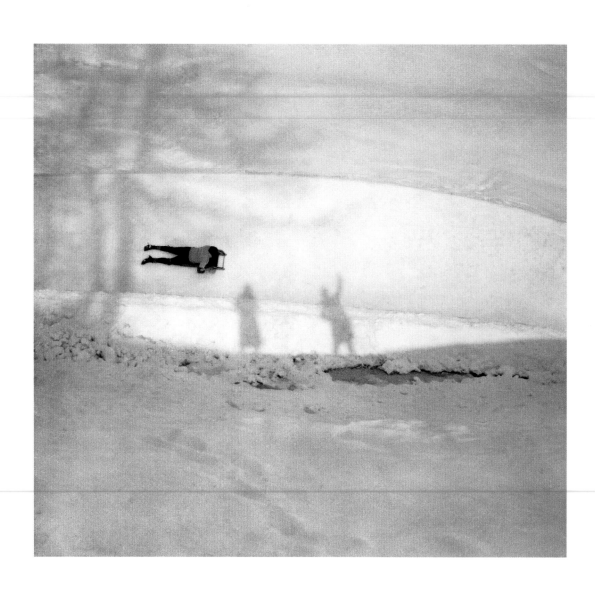

PRECEDING DOUBLE PAGE Skier falling, Chamonix, France, January 1919.

ABOVE Skeleton championship, Cresta Run. My and Zissou's shadows, Saint Moritz, Switzerland, February 1913.

FACING PAGE While I still have a shadow, Saint Moritz, Switzerland, February 1980.

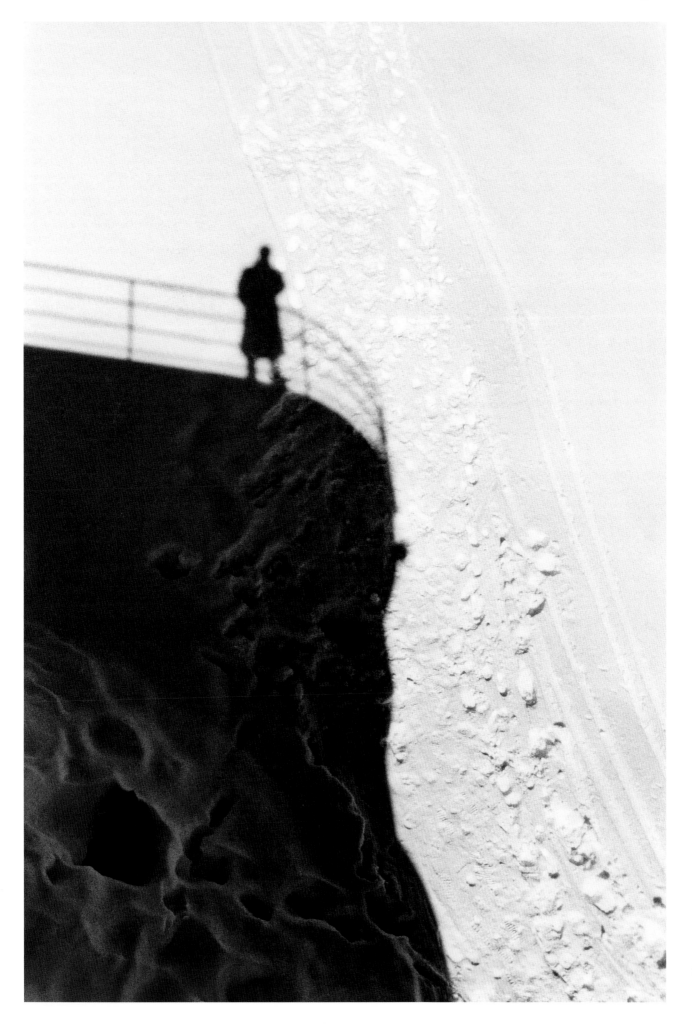

FACING PAGE Ostertag, Chamonix, France, January 1918.

FOLLOWING DOUBLE PAGE Perilous ski jump, Megève, France, January 1930.

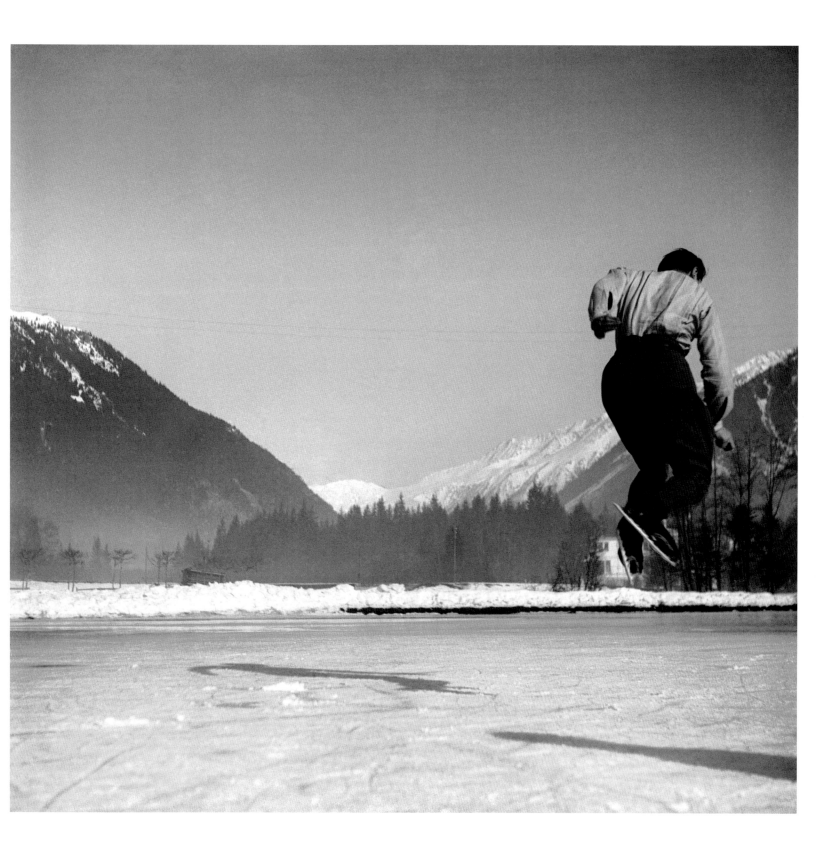

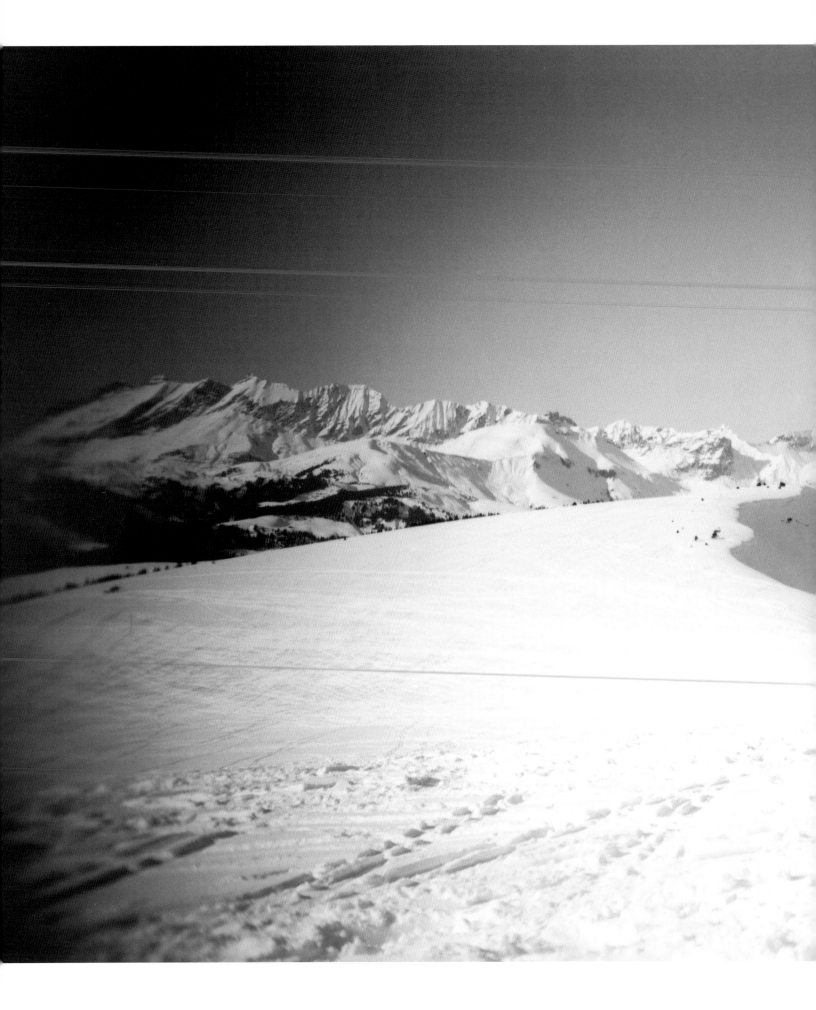

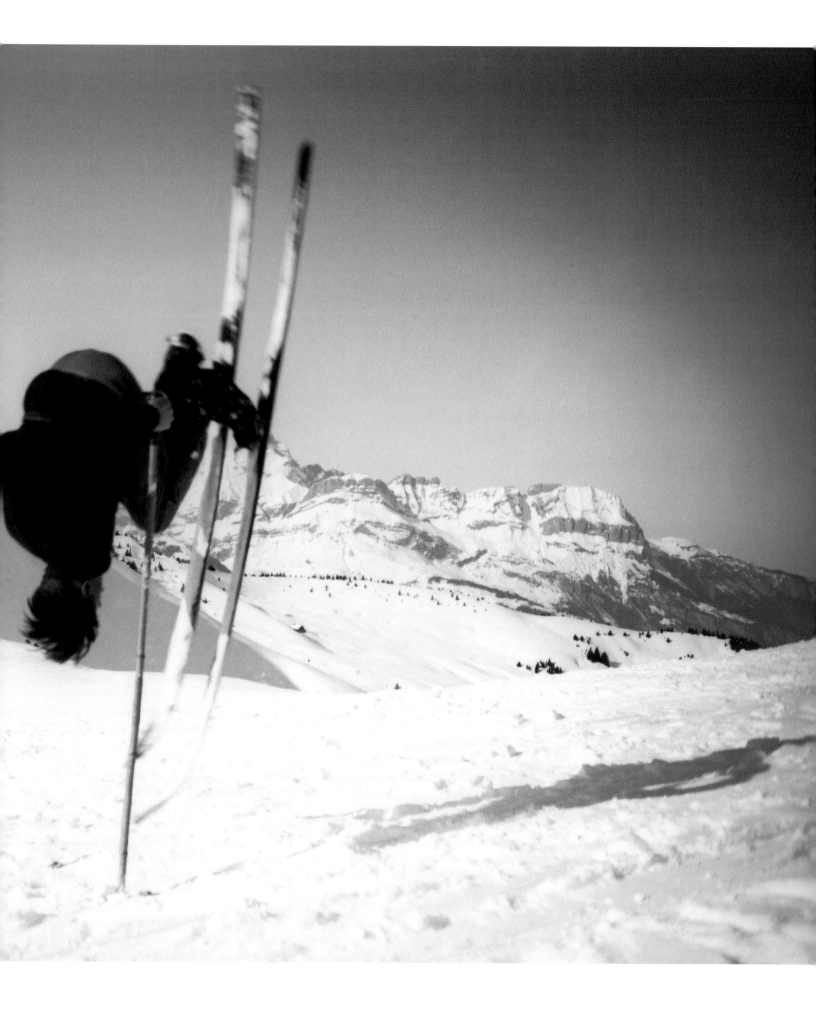

"I would have liked…I would have liked…I would like…
I would like to express everything, remember everything.
I'm drugged without drugs. A drugged man imagines
himself to be a genius, and then when he sees a tangible
reflection of his fantasies he realizes they were as mediocre
as the ones he normally has. Only with me it isn't thought
that I want to catch in a trap but the smell of my happiness!
I've been bodily seized by an indefinable sensual delight
that's paralyzing me…and will go on paralyzing me
until I think I have crystallized it".

Neuilly, France, January 25, 1928

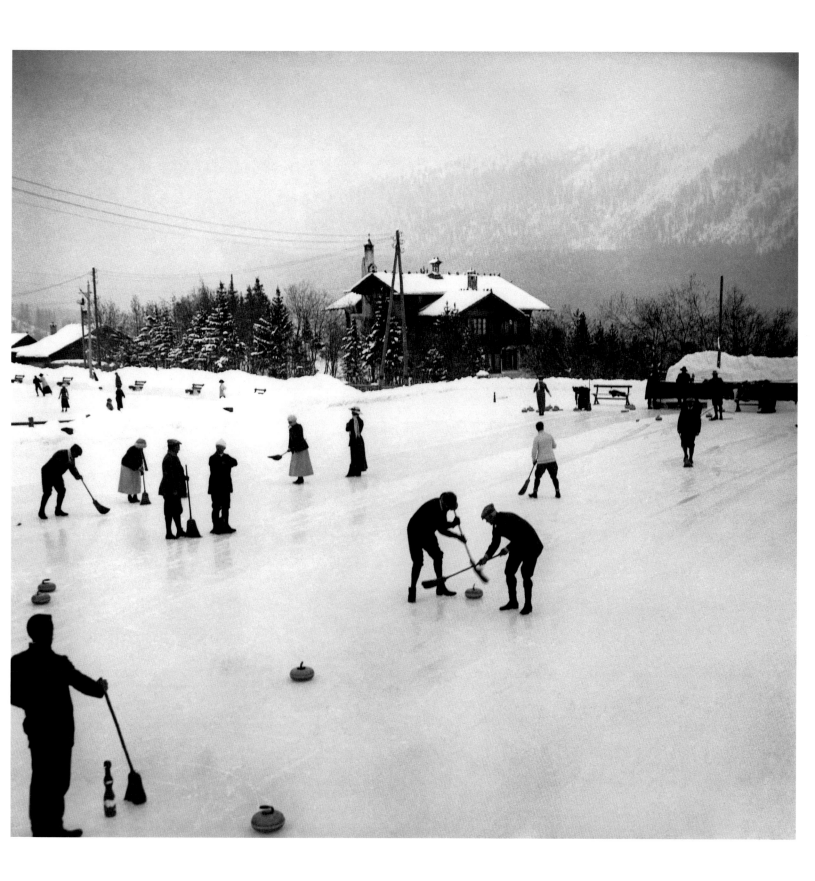

Ophélia da Costa, Chamonix, France, January 1914.

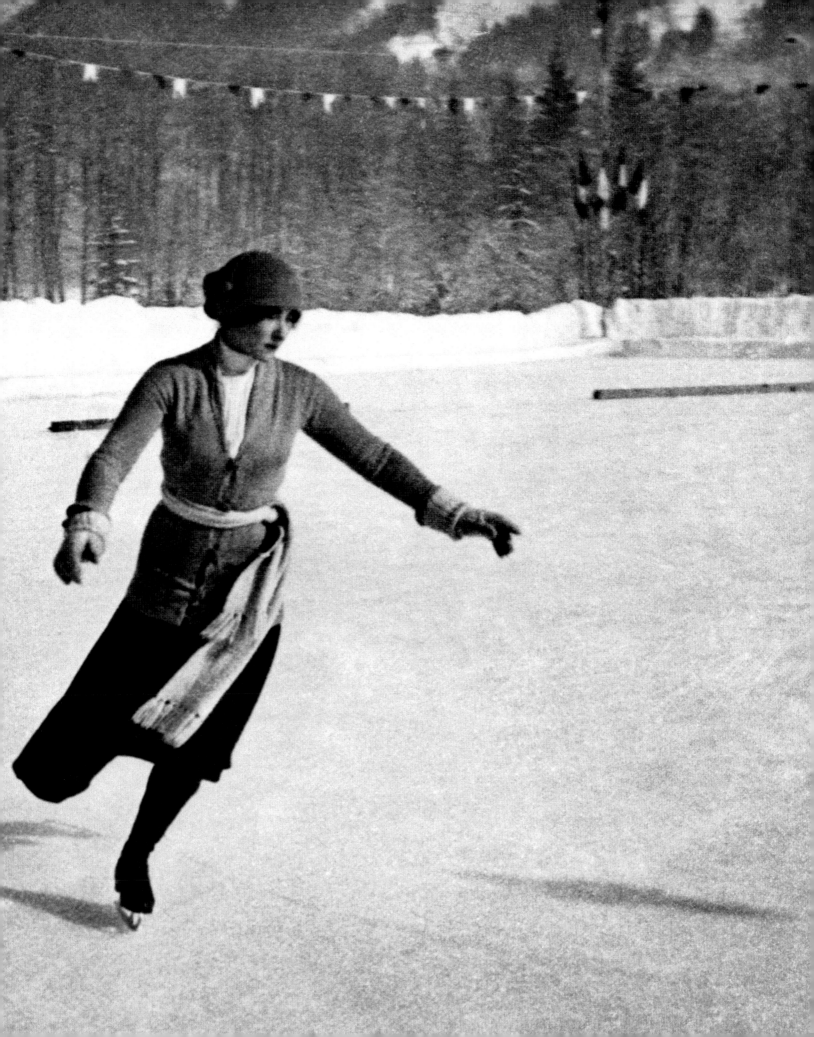

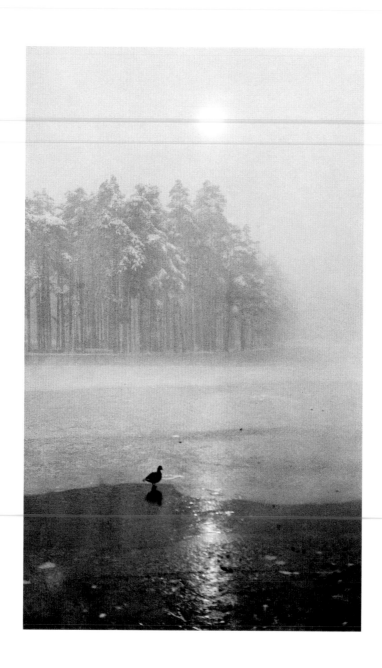

ABOVE Bois de Boulogne, Paris, December 1925.

FACING PAGE Marcelle Bouriou and Jean Dary, skating at the Tir aux Pigeons, Paris, December 1917.

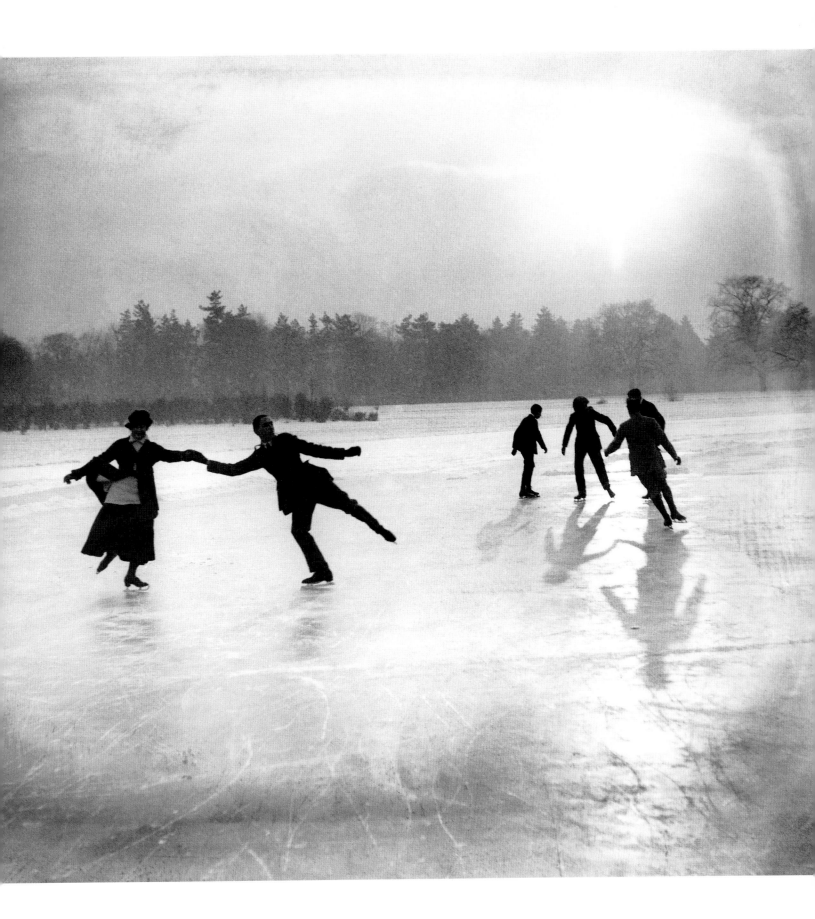

JANVIER : CHAMONIX (COL DE VOZA)

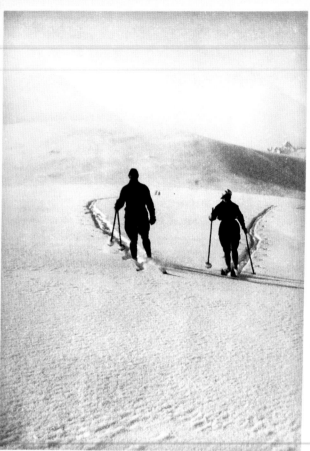

JEAN MALVINA

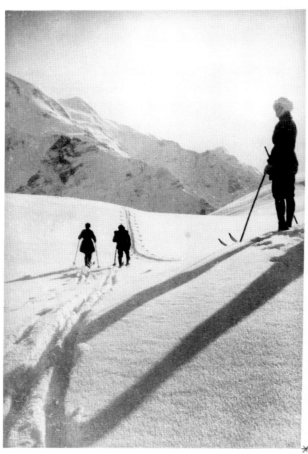

MALVINA

"My sealskins on, cold, upward I go."

"Other words will have to be invented
when one decides to describe paradise."

Saint Moritz, Switzerland, January 1913

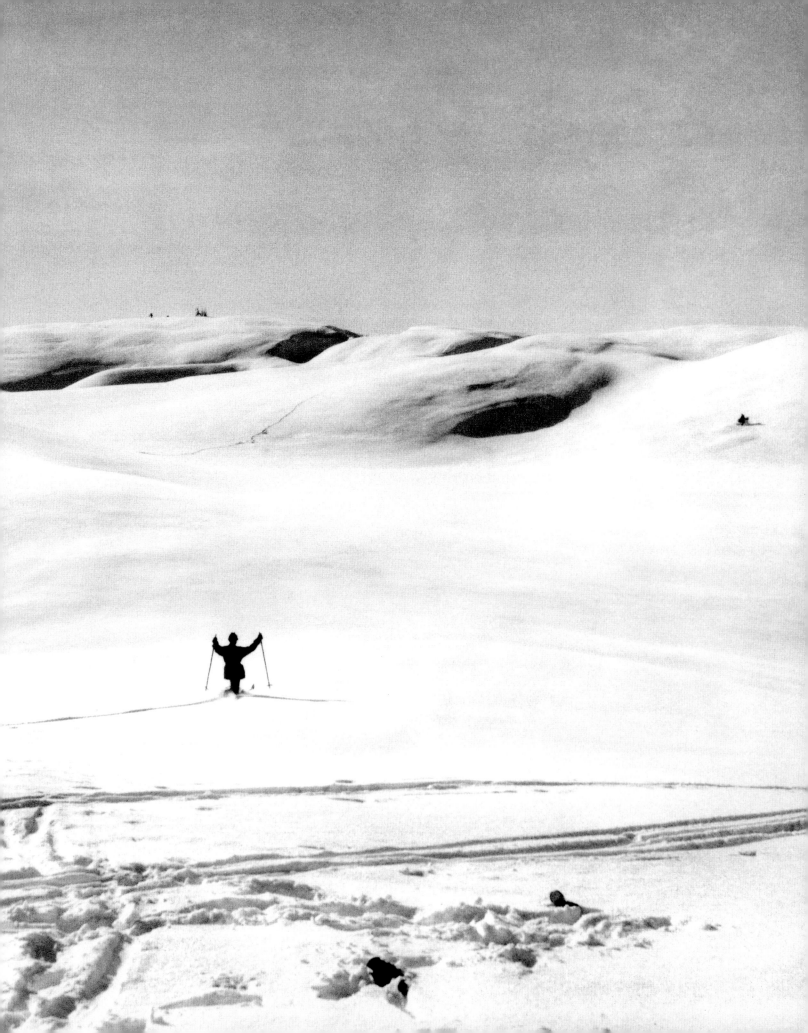

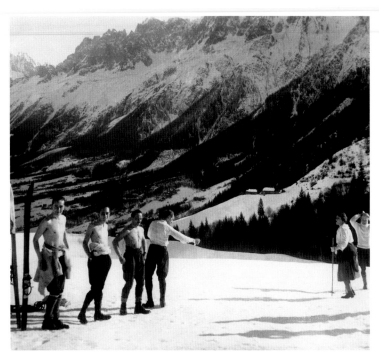

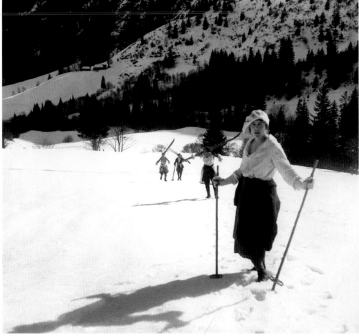

ABOVE LEFT Me, Zyx, Pigueron, and Heïdé, Chamonix, France, January 1918.

ABOVE RIGHT Malvina, Chamonix, France, January 1918.

128 FACING PAGE Dani, Megève, France, January 1930.

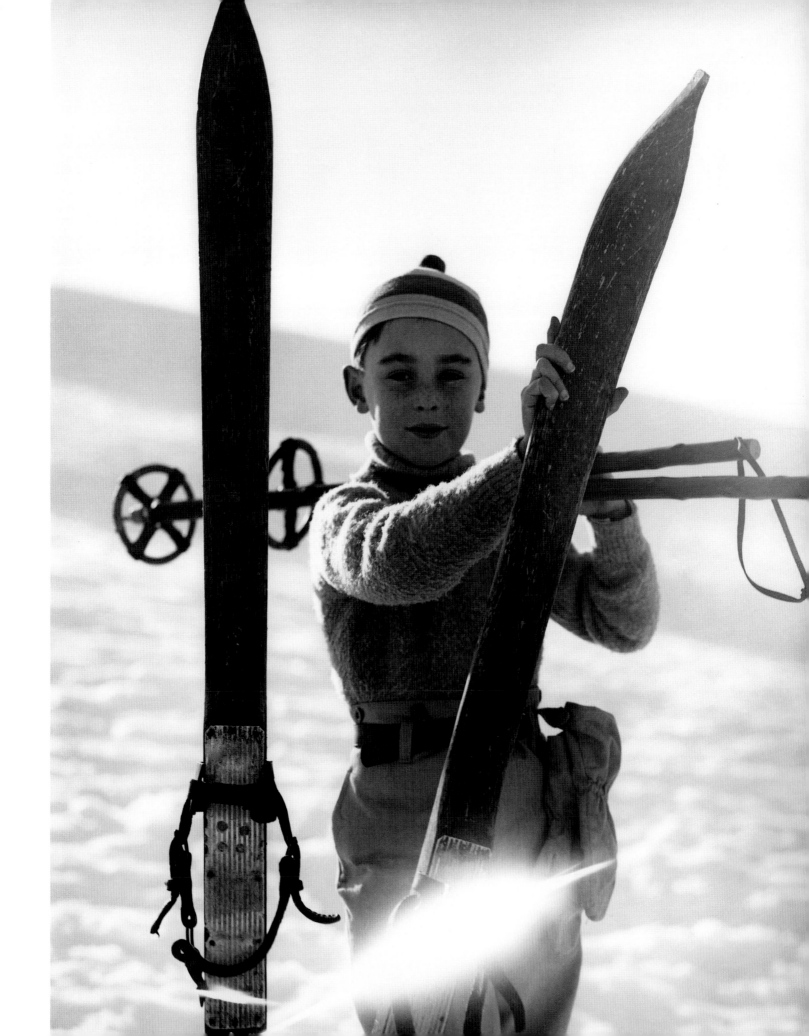

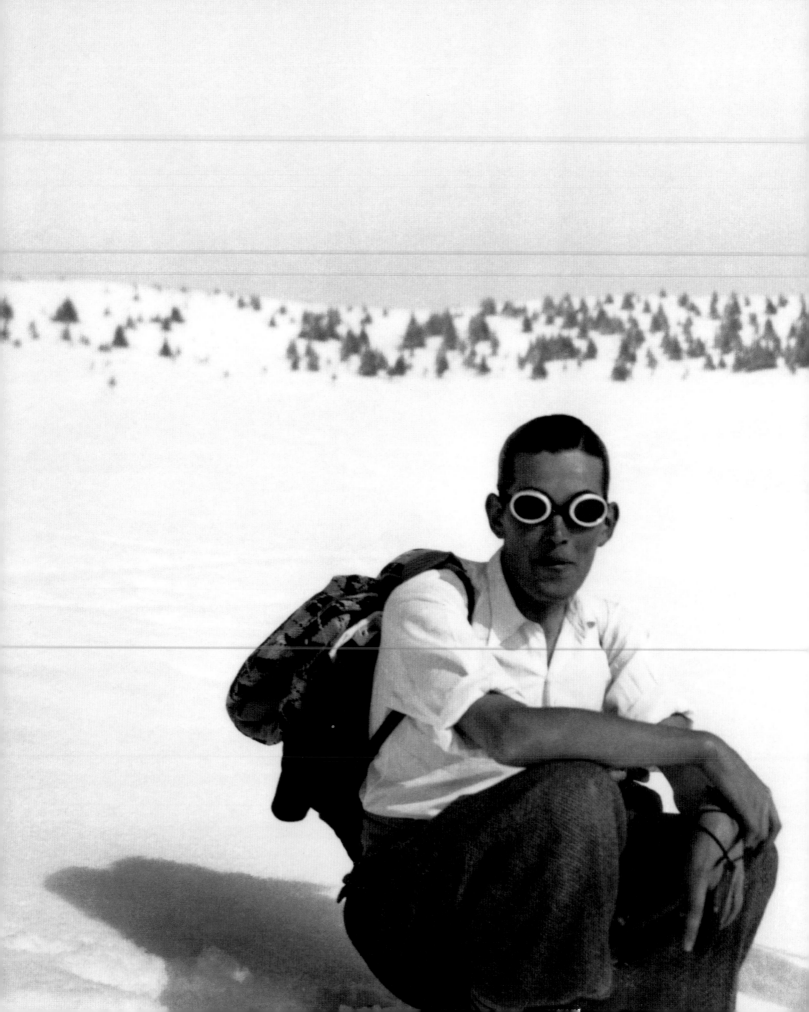

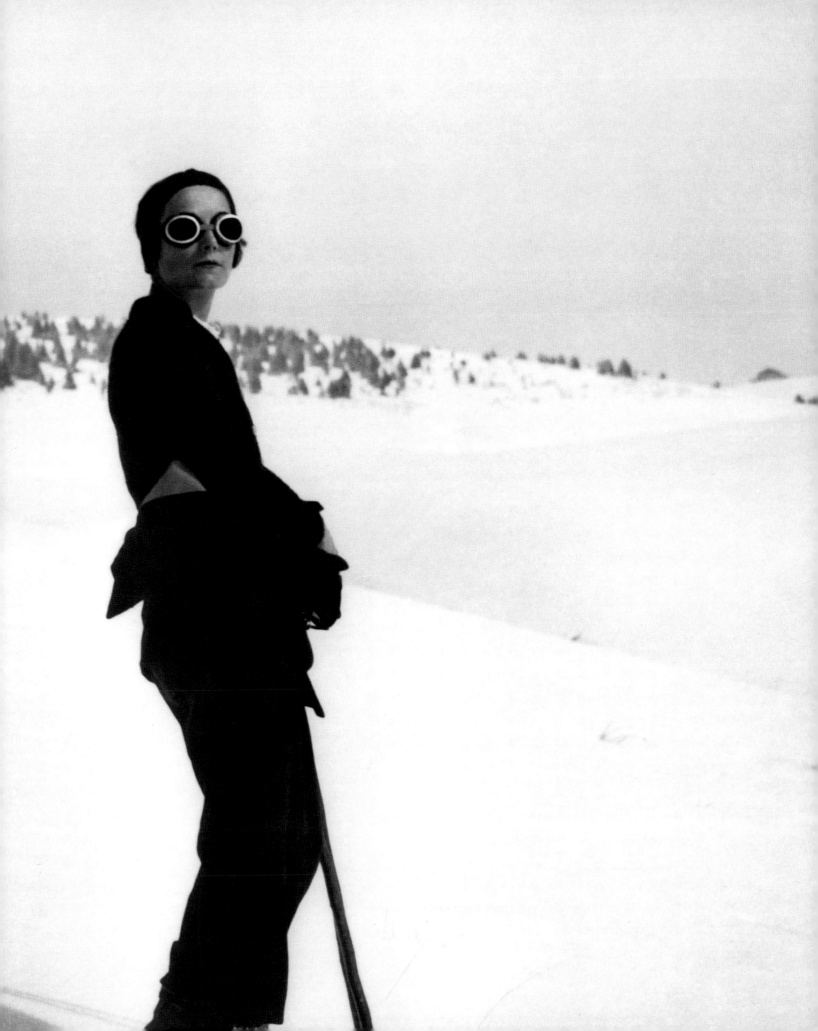

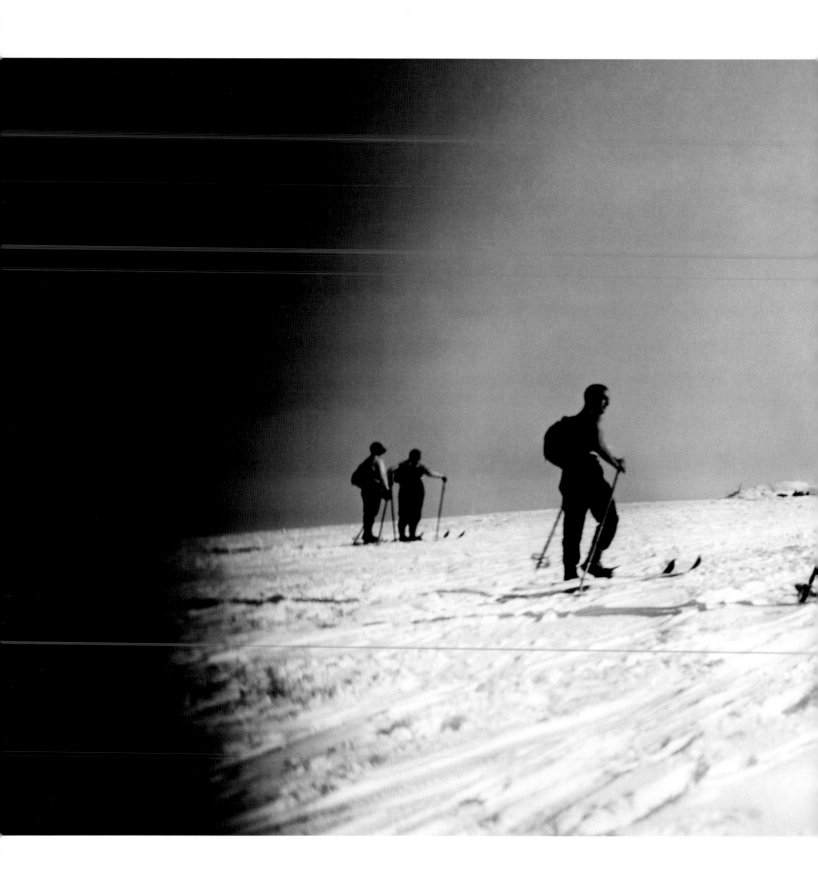

PRECEDING DOUBLE PAGE Doudy de Cazalet with an unidentified woman, Megève, France, February 1933.

ABOVE The climb to the Col d'Arbois, the first to arrive, Megève, France, January 1930.

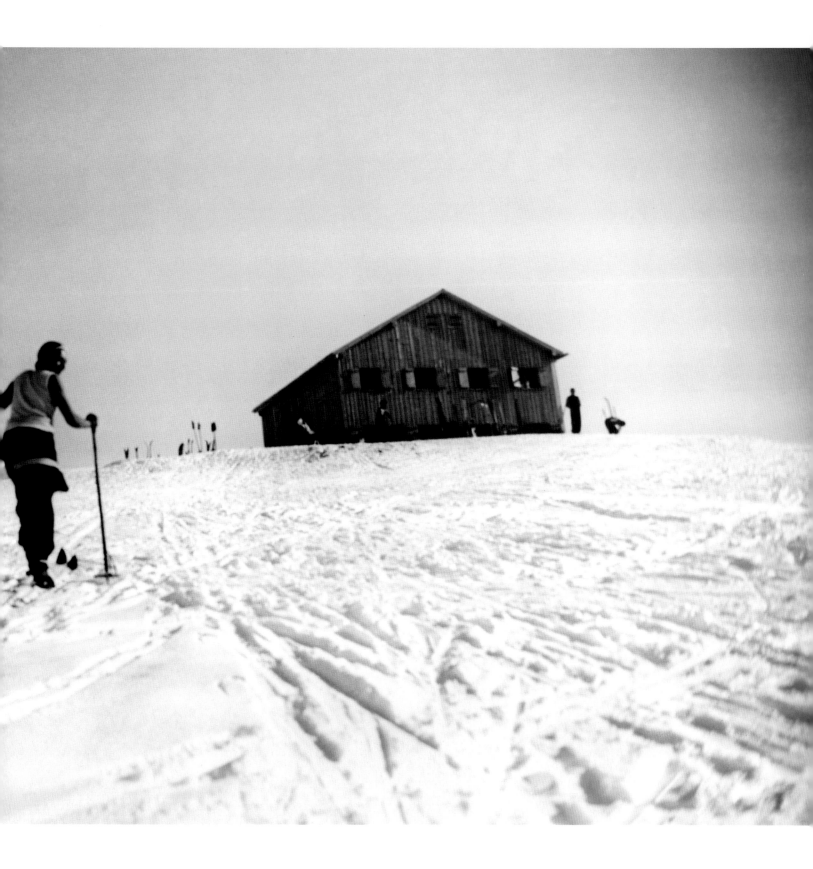

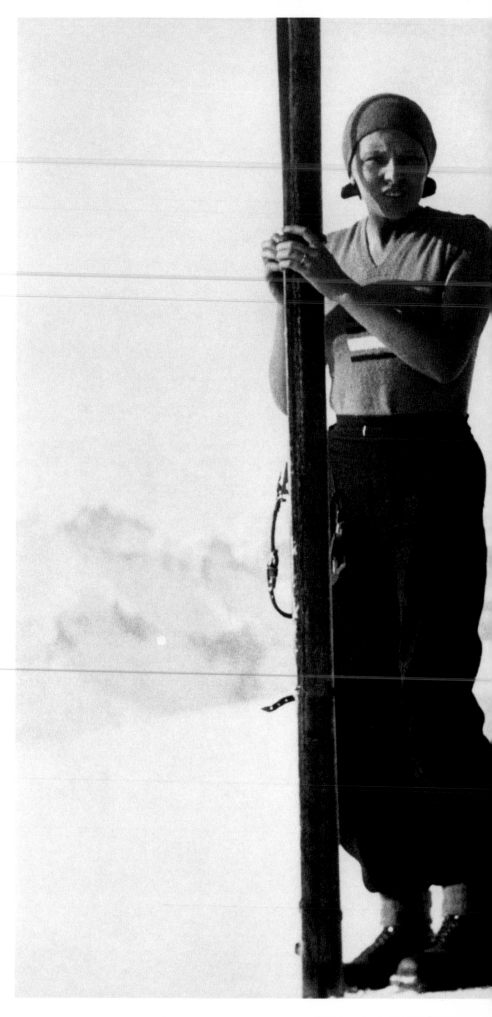

"Closing my eyes, I see everything. It all seems
so simple and marvelous. But as soon as I want
to express it, it becomes muddled, comes out
in a commotion and drives me to despair.
In my ocular memory, I see Doriane, magnificent,
her Vaselined face shining in the sun.
Queen of Megève that year with her slim
hips and breast-clinging Hermès sweaters.
I see Mano's tender look and her big painted
mouth…her aquamarine eyes and prominent
cheekbones…. And then I see…I see above
all the indefinable color of the light,
its crudeness as appetizing as the air's."

Megève, France, January 1930

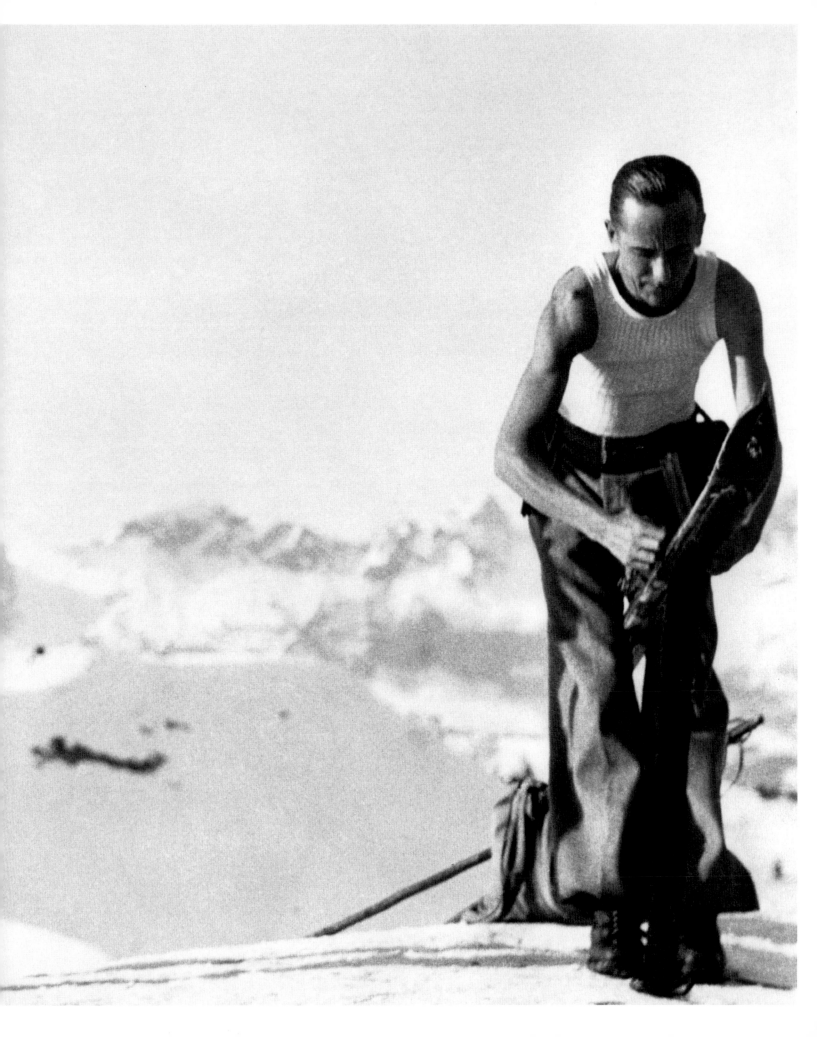

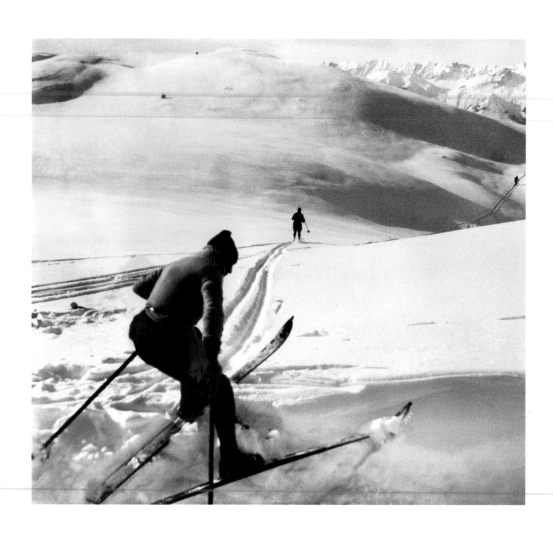

ABOVE Malvina, Col de Voza, Chamonix, France, January 1919.

FACING PAGE Jean and Malvina, Chamonix, France, January 1919.

136 FOLLOWING DOUBLE PAGE Megève, France, February 1933.

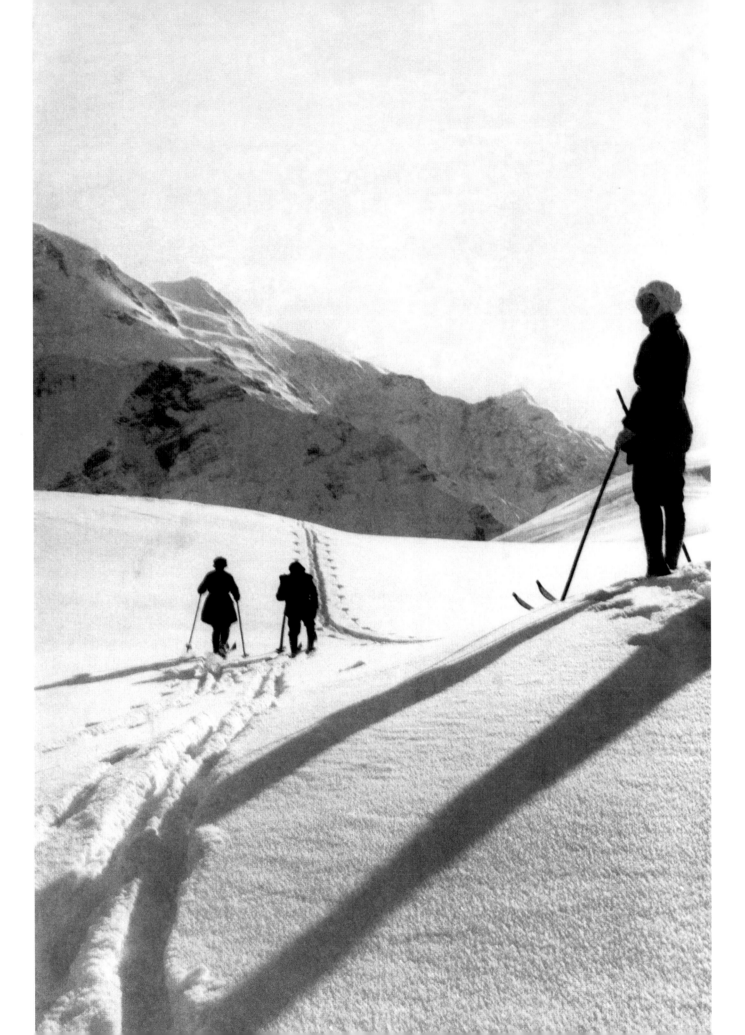

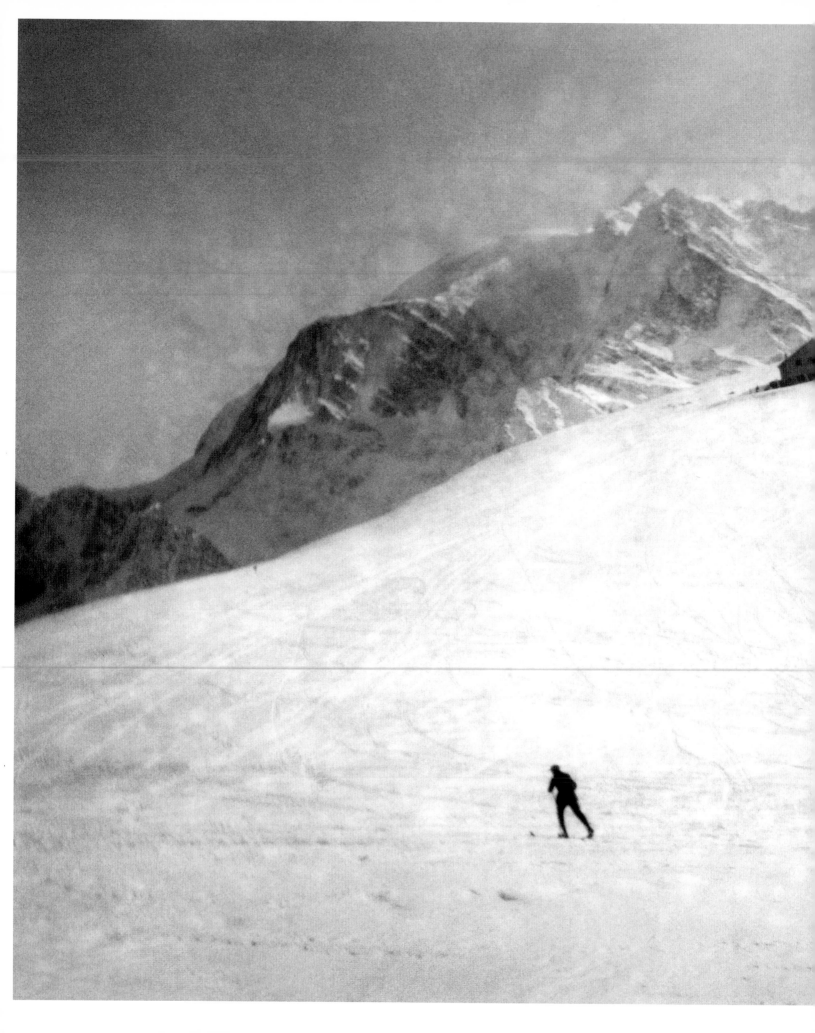

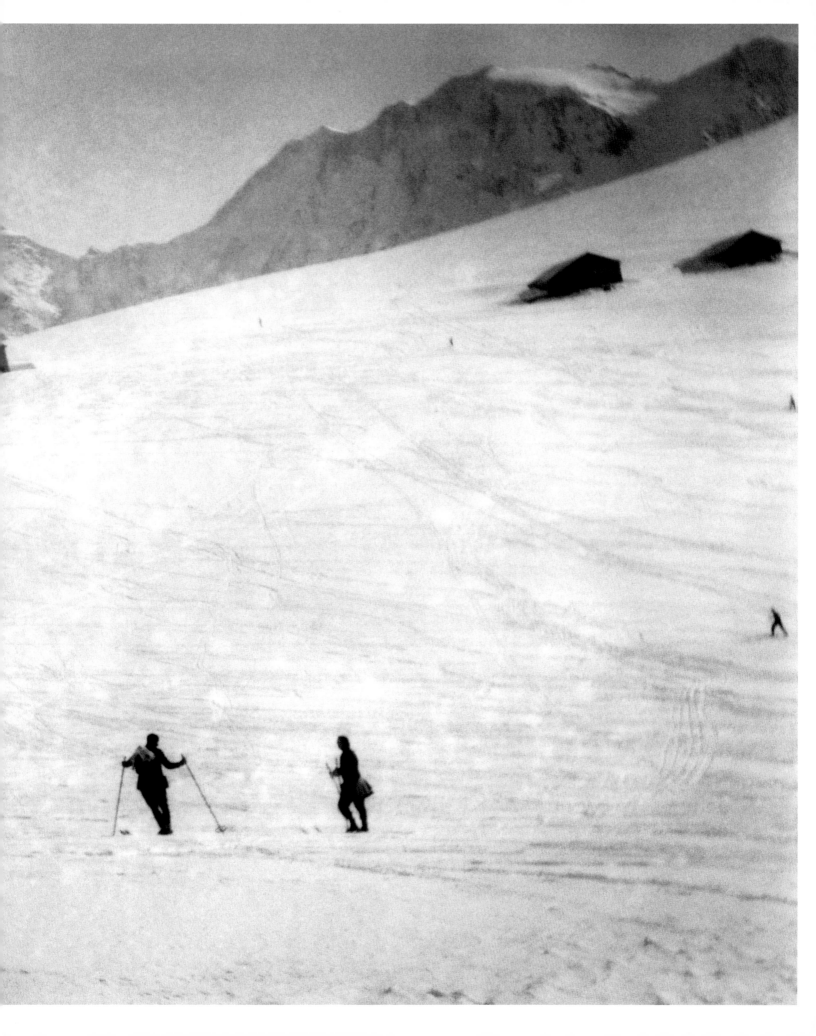

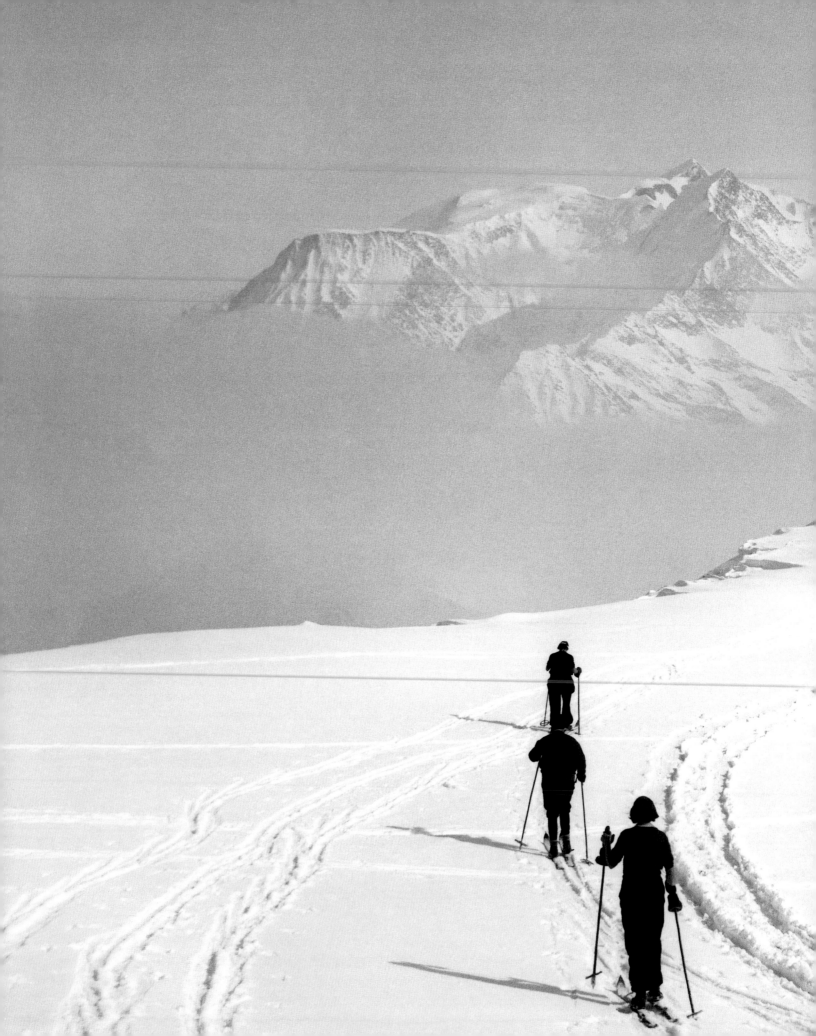

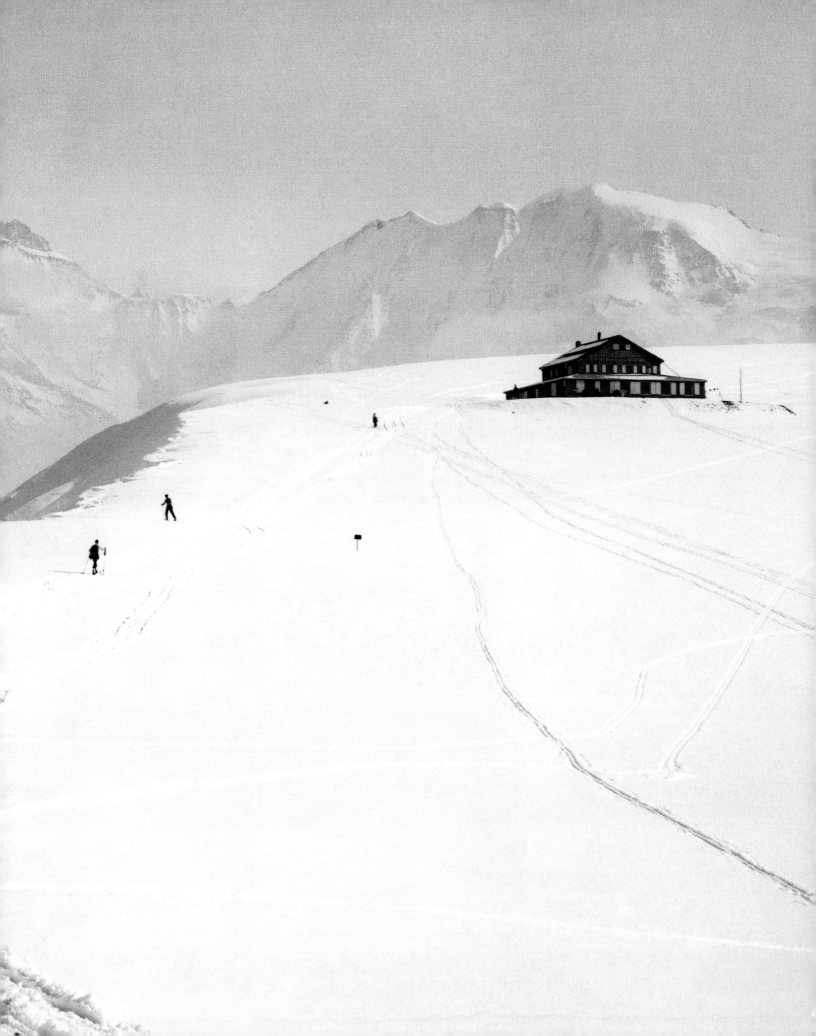

"Today I couldn't care less about anything. Everything
has been erased inside me and outside me by the dazzle
of the sun. I left the little village full of muddy slush
and tourists dressed up in their 'valiant mountaineer'
costumes and, lunch on my back, I climbed to find the snow
near my little chalet of last year, motionless in its desert
of light. In the immense silence, as though hanging in the air,
it was waiting for me as if all that I had done since the last
time had been only an interlude in this paradise.

 Only a blank page could express all that is inexpressible:
unpaintable, unretainable; the snow, the sun, youth,
the blue shadows, the silence of the sky, the bottom
of whose skirts one enters in the high mountains…,
a virgin desert dazzling like a fragment of pure light, like a girl
with her hair blowing in the wind, the thought of whom
one takes down with one on those crazy descents…"

Megève, France, February 16, 1933

PRECEDING DOUBLE PAGE The climb to the Col d'Arbois, Megève, France, January 1930.

FACING PAGE Chamonix, France, January 1918.

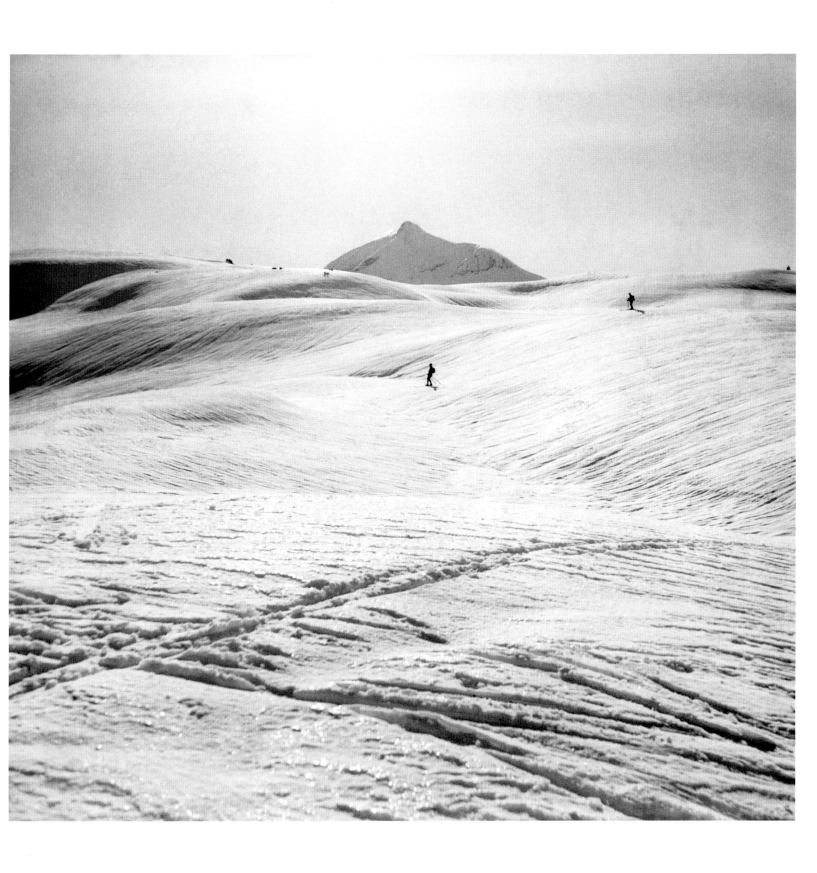

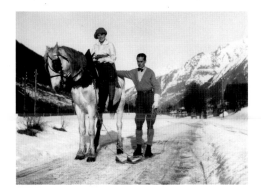

Chronology

1894 Birth of Jacques Henri Lartigue on June 13, at Courbevoie. His father, a businessman, introduces him to photography, later giving him his first camera when he is seven.

1902 Jacques Lartigue takes his first photograph, entirely unassisted. He starts keeping a diary, and does so throughout his life, noting down his daily thoughts, impressions, and reflections. He also begins to fill albums with photos chronicling his private and family life.

1904 Very quickly, he is attracted by movement. Ingeniously exploiting technological advances, he takes his first action photographs (jumps, games, sports, etc.). He photographs every trial and experiment by his brother Zissou and his cousins at Pont-de-l'Arche or at Rouzat. Other favorite subjects are airplanes and automobiles, sports events, and the beautiful women in the Bois de Boulogne.

1913 In January, Lartigue vacations at the winter-sports resort of Saint Moritz. He photographs the filmmaker Max Linder at the wheel of a bobsleigh and his cousin Simone, who came third in the world ice-skating championships, with champion Charles Sabouret.

1914 In January, in Chamonix, he films de Lesseps on his propellor-driven sledge and photographs the new sports: skijoring, ski jumping, bobsleigh-racing, ice hockey, and skating.

1915 Attends the Académie Jullian. Painting becomes and remains his principal professional activity.

1918 From January 10 to January 31, stays in Chamonix at the Hôtel des Alpes. Photographs the three leading skating champions of the time, Pigueron, Heïdé, and Ostertag.

1919 Returns to the Hôtel Savoy in Chamonix from January 6 to January 31.
On December 17, he marries Madeleine "Bibi" Messager, daughter of the composer André Messager.

1920 Honeymoon at Chamonix, January 7 to January 22.

1921 Birth of their son Dani on August 23. Meets numerous artists and writers, performers, and sports champions, some of whom become his friends; frequents cinema circles and photographs the shooting of films by Jacques Feyder and Abel Gance, and then later by Robert Bresson, François Truffaut, Federico Fellini, and others.

1930 Holidays in the snow at Megève with Bibi, Dani, Michèle Verly, Arlette Boucard, Doriane, among others. Treks on the Col d'Arbois.

1932 Stays at Megève from February 10 to March 5.

1933 Returns to Megève, February 14 to March 1.

1934 Marries Marcelle "Coco" Paolucci, a fashion-magazine illustrator. He is now known as the art director of major town festivals at Cannes, La Baule, and Lausanne.

1939 In February, at Villard-de-Lans, he photographs the shooting of scenes from the movie La Loi du Nord by Jacques Feyder, based on the novel by Constantin-Weyer, starring Michèle Morgan, Charles Vanel, and Paul-Émile Victor.

1941 Returns to Megève in February with Micheline Presle and friends.

1942 Marries Florette Orméa, who remains his companion for the rest of his life.

1956 Stays briefly in Megève, as he will in 1961, 1963, and 1964.

1963 An exhibition at the Museum of Modern Art, New York, and the publication of a feature article in Life magazine are seminal events in the recognition of Lartigue as a photographer.

1966 Publication of The Family Album, whose international edition largely contributed to the popularizing of Lartigue's work.

1970 Publication of Diary of a Century. The book, designed by Richard Avedon, revealed for the first time photographs taken after 1930.

1975 The first retrospective of his work in France, Lartigue 8 x 80, at the Musée des Arts Décoratifs, Paris.

1979 On June 26, Lartigue bequeaths his entire photographic oeuvre to the French State.

1980 Last stay at Saint Moritz, February 20 to March 1.

1981 Last stay at Megève, March 3 to March 9.

1985 The exhibition, Le Passé composé– Les 6 x 13 de Jacques Henri Lartigue, presented first in Arles and then at the Grand Palais in Paris, travels to several American museums including the Museum of Modern Art in New York and the Art Institute of Chicago (1987).

1986 Lartigue dies in Nice on September 12. At his funeral, he is awarded the Legion of Honor.